FEDERICO ZERI (Rome, 1921-1998), eminent art historian and critic, was vice-president of the National Council for Cultural and Environmental Treasures from 1993. Member of the Académie des Beaux-Arts in Paris, he was decorated with the Legion of Honor by the French government. Author of numerous artistic and literary publications; among the most well-known: *Pittura e controriforma*, the Catalogue of Italian Painters in the Metropolitan Museum of New York and the Walters Gallery of Baltimora, and the book *Confesso che ho sbagliato*.

Work edited by FEDERICO ZERI

Text
based on the interviews between
FEDERICO ZERI and MARCO DOLCETTA

This edition is published for North America in 1999 by NDE Publishing*

Chief Editor of 1999 English Language Edition
ELENA MAZOUR (*NDE Publishing**)

English Translation
RAMAN A. MONTANARO

Realisation
CONFUSIONE S.R.L., ROME

Editing
ISABELLA POMPEI

Desktop Publishing
SIMONA FERRI, KATHARINA GASTERSTADT

ISBN 1-55321-000-X

Illustration references

Alinari archives : 1, 2-3, 5, 6, 8-9, 14-15, 16-17, 17b, 20-21, 22bl, 29br, 30b, 31l, 32r, 37b, 40-41, 42, 44, 45.

Luisa Ricciarini Agency : 16b, 21tr, 23, 24tr.

RCS Libri Archives: 2t, 7, 10-11, 12-13, 18tr-b-c, 19, 20c, 21tr, 24, 26tr, 28l, 29ts-tr, 33lb, 33, 34-35.

R.D.: 3tr, 4, 14t, 15t, 17t-c, 18tl-c, 20t-b, 21b, 22tl-tr, 25, 26tl-bl-br, 27, 28r, 30t, 31r, 32tr-c, 36, 37t, 38, 39, 40l, 41r, 42, 43, 44, 45, 46b, 47.

The details of the restoration at pages 13-14-15 have been granted
by the Italian Ministry of Cultural Assets end Environment

Printed and bound by Poligrafici Calderara S.p.A., Bologna, Italy

* a registred business style of NDE Canada Corp.
 18-30 Wertheim Court, Richmond Hill, Ontario
 L4B 1B9 Canada, tel. (905) 731-12 88

The captions of the paintings contained in this volume include, beyond just the title of the work, the dating and location. In the cases where this data is missing, we are dealing with works of uncertain dating, or whose current whereabouts are not known. The titles of the works of the artist to whom this volume is dedicated are in blue and those of other artists are in red.

LEONARDO
THE LAST SUPPER

"One of you will betray me": These words, just uttered by Christ to the apostles, animate the scene of THE LAST SUPPER, in which the viewer, entering the refectory of the convent of Santa Maria delle Grazie in Milan, finds himself involved. The genius of the painter and that of the scientist are combined in the perspective so-

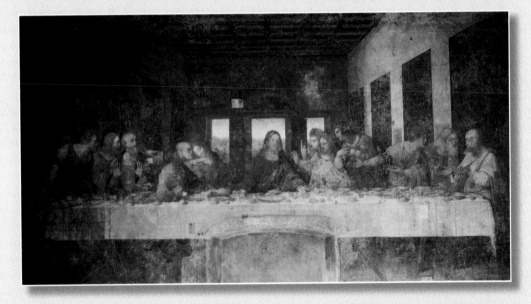

lution found by Leonardo to have the observer a participant in the event: the real surroundings continue into the artificial one, the perspective is carried out on the wall at the end of the room on which the scene is painted, creating a new, dramatic relationship between the observer and the evangelical event.

DEVELOPMENT OF AN EVENT

THE LAST SUPPER
1495-1499
● Milan, refectory of the convent of Santa Maria delle Grazie (tempera on plaster, 460cm x 880cm)

● The work was carried out starting in 1495, the year in which Ludovico il Moro commissioned Leonardo da Vinci, already in the service of the Sforza family of Milan since 1482, with the painting.

● The fresco used to occupy the entire wall at the end of the refectory (dining-hall) of the Dominican convent, but today we only see the rectangle containing *The Last Supper*. The great box in which the scene used to unfold continued even upwards, between the arches dis-

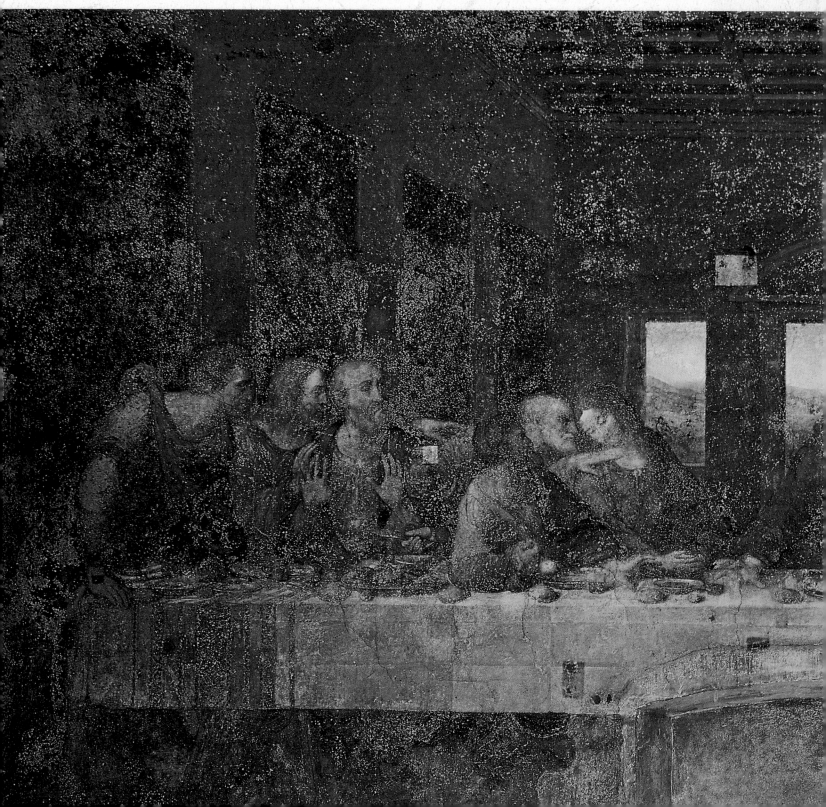

playing the heraldic devices of the Sforza family, and in the part below, where the floor was simulated. In the construction of an extremely rigorous scientific perspective, Leonardo put the entire wall to use, in such a way that whoever entered the main door would find themselves before a real environment that continued into the artificial environment of *The Last Supper*.

● The whole composition is scientifically tied to its geometric construction, and is in fact perfectly divisible into squares, from which are traceable the diagonals, which contain and delimit the working of the scene. But this, rather than fixing it into the rigidity of the classical mold, gives it dramatic force, due to the various placements of the apostles around the table and due to their gestures, done in a completely new way in the Italian and European fresco painting. A sort of multiple dialogue is created between the various persons, and between them and Christ, a dialogue that today is in part frustrated by the fact that the painting, more than just being devastated on the surface, has extremely washed-out colors.

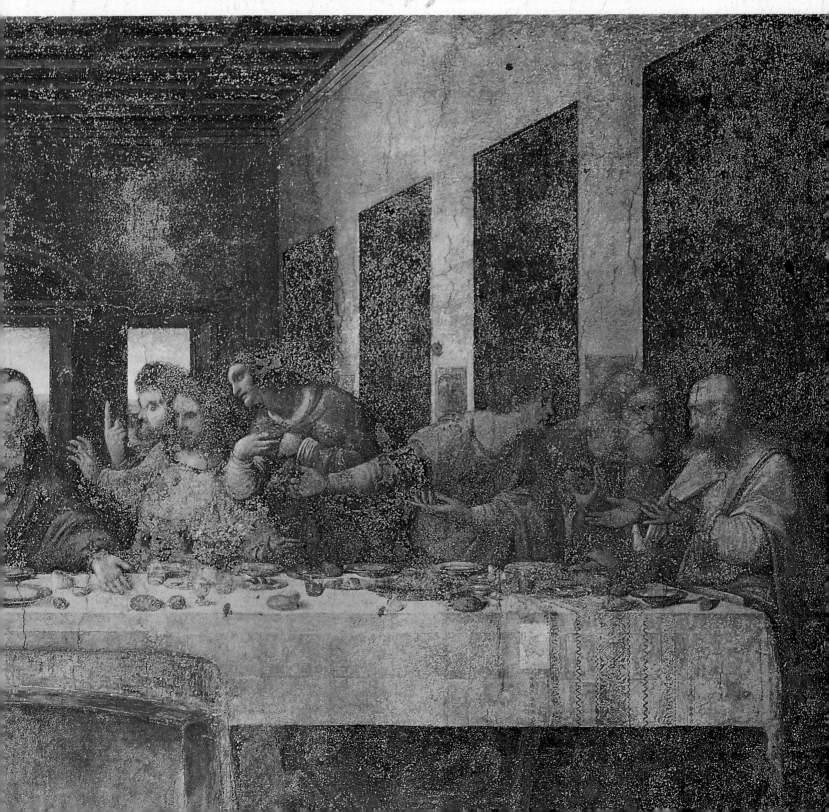

IN THE CONVENT REFECTORY

The church of Santa Maria delle Grazie, among the most representative creations of the Renaissance in Milan, was erected between 1466 and 1490 as the work of G. Solari, and enlarged in 1492 by Bramante. Next to the church, in the former Dominican convent, is the refectory.

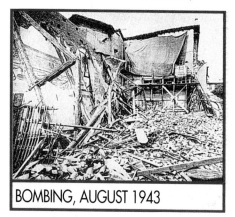

BOMBING, AUGUST 1943

● The fresco, escaping destruction during the bombing of August 1943, was badly damaged. The first problems date back to the age of the French occupation (1499), when the refectory was requisitioned and transformed into a stable. At that time a door was even opened in the back wall. Following this, the vibrations sustained by the wall provoked a series of degradations which first involved the outermost surface, that is, the skin of the fresco, then penetrated even in depth.

● In the last century, with the deepening of the research around the masterpiece of Leonardo, began – unfortunately – restorations, not only to conserve, but also to clean and integrate. These were superimposed until the pictorial quality of *The Last Supper* was altered. Finally, various phases of cleaning eliminated the most superficial touch-up work, leaving the true outermost layer of paint, or what had remained of it under cover. Only recently, an excellent cleaning by Pinin Brambilla has removed the deepest touch-up work, revealing stunning never-before seen details: for example the luster on the metallic plates, or the tablecloth's weave.

SANTA MARIA DELLE GRAZIE REFECTORY

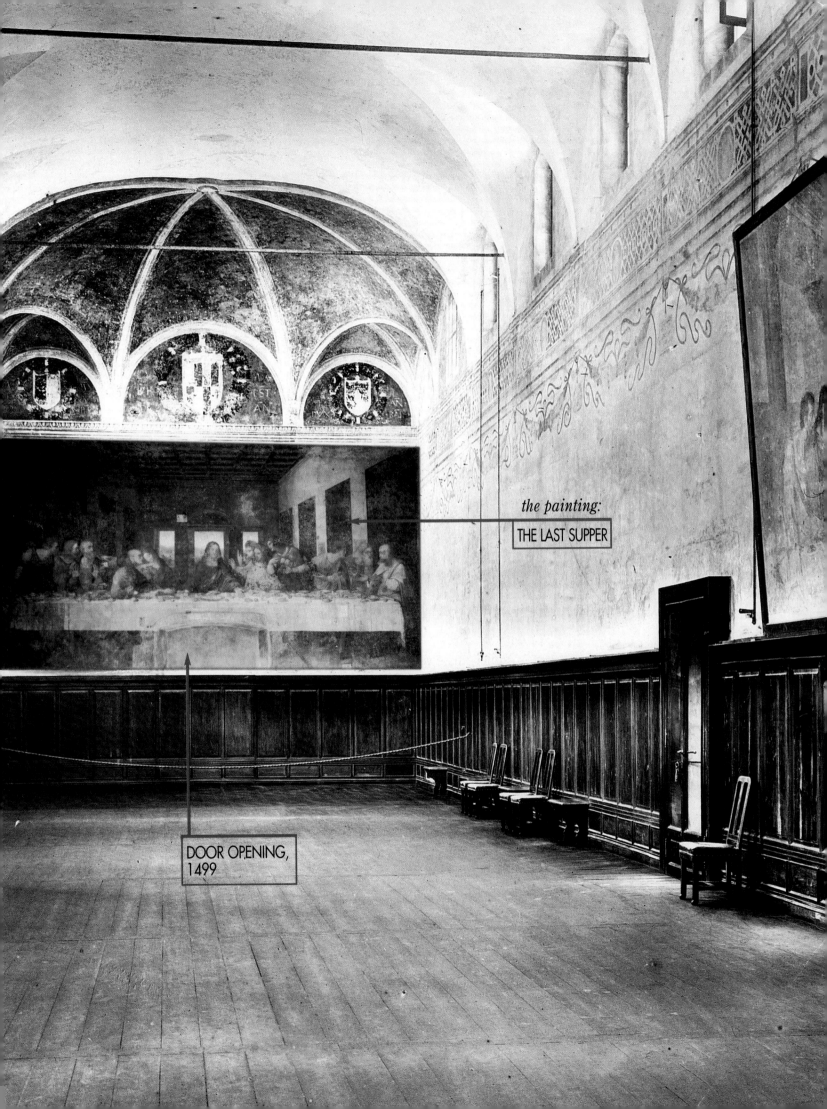

the painting:
THE LAST SUPPER

DOOR OPENING, 1499

A MULTIPLE DIALOGUE

The rigor of the geometric construction enabled Leonardo to subdivide the scene into four quarters, and to insert the twelve apostles into each one of these, setting them in groups of three. Among these, the figure of Judah is easily distinguishable (quarter on the left), holding with his right arm on the table the sack of thirty coins he received. The scene is composed of four groups of apostles placed two each on the sides of the central figure of Christ, inserted in a perfectly triangular space, who has just announced that one of them would betray him.

● This composition appeared to some critics overly schematic, and they even reproached Leonardo for excessively underlining the gesticulations of the figures, and for a certain obviousness in

◆ THE ABSOLUTE GESTURE
The figure of Jesus, enclosed in an ideal triangle, expression of the Divine Trinity, is absorbed in the institution of the Eucharist. Christ is indicating with his hands the wine and the bread on the table as a sign of the sacrifice for which he is preparing. His immobility represents that "Prime Mover" from which all actions spring, and toward which they

return, giving life to a complex movement of gestures. Luca Pacioli (mathematician and theorist of painting, contemporary and friend of Leonardo), who saw *The Last Supper* in 1498, referring to the figure of Christ, defined it as the "image of the burning desire for our salvation".

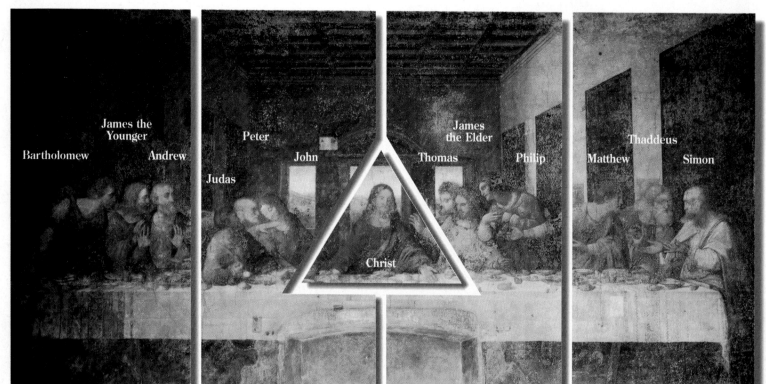

Bartholomew — James the Younger — Andrew — Peter — Judas — John — Christ — Thomas — James the Elder — Philip — Matthew — Thaddeus — Simon

the various feelings expressed by the individual apostles while they discussed the words of Christ or addressed him: the Apostle Philip, for example, stricken with grief, brings his hands to his chest in a sign of affection and participation.

● This may be true, but it is also just these conventional gesticulations of the individual characters, animatedly relating among themselves, which gives an altogether unique dramatization to the whole. The gestures of the hands, the agitated questioning, and the expressions of anxiety move the scene around the absolute gesture of Christ, to which all is related.

◆ THE RHYTHMIC SCAN OF THE SCENE
The traditional iconography of the Last Supper – largely used by fifteenth century painters from Tuscany such as Il Ghirlandaio and Andrea del Castagno – called for Judas to be seated by himself on the opposite side of the table, across from the other eleven apostles.

The difference in his placement served to immediately reveal his betrayal. Leonardo, on the contrary, introduces an absolute novelty: entrusting to expression and gesture the secret that only Judas and Jesus know, and placing the traitor among the others to make the self-interrogation of the apostles even more

intensely dramatic. The theatrical taste with which Leonardo stages the evangelical episode reveals itself in the care with which he constructs the dialogue between the four groups of apostles, set in clusters of three, in a fluid continuum of gestures and movements scanning the space bound by the shadows.

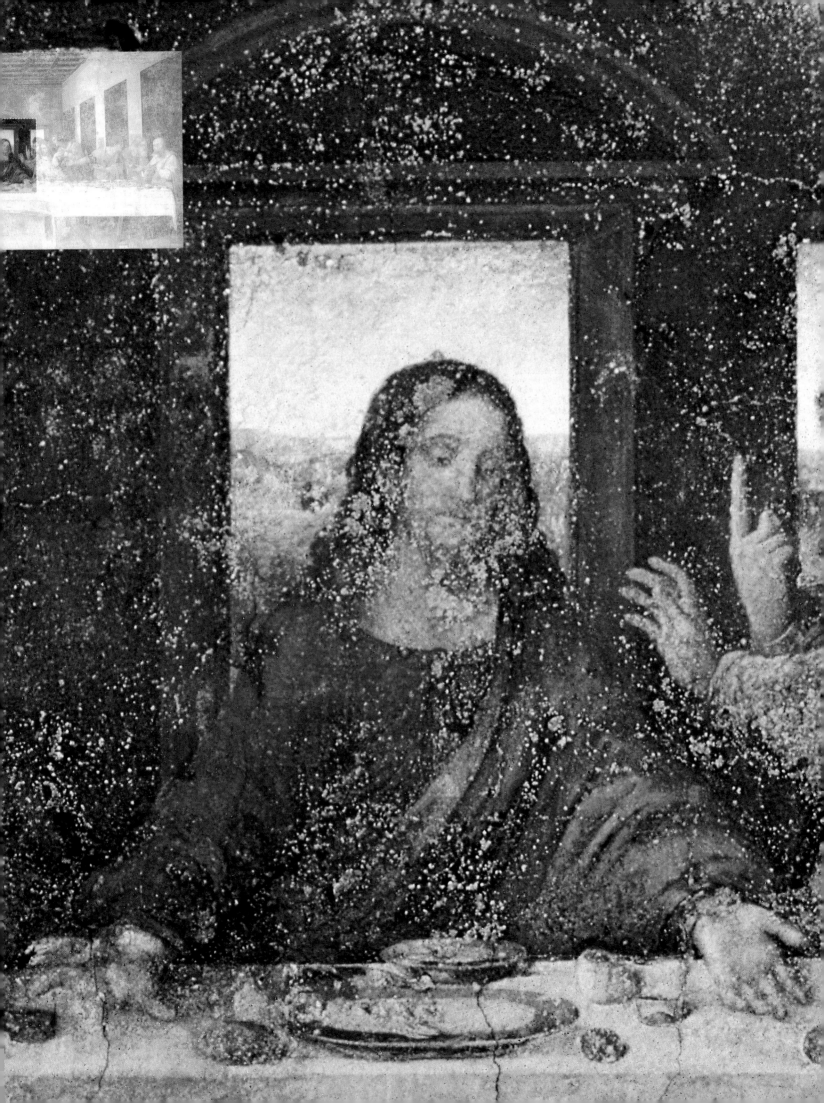

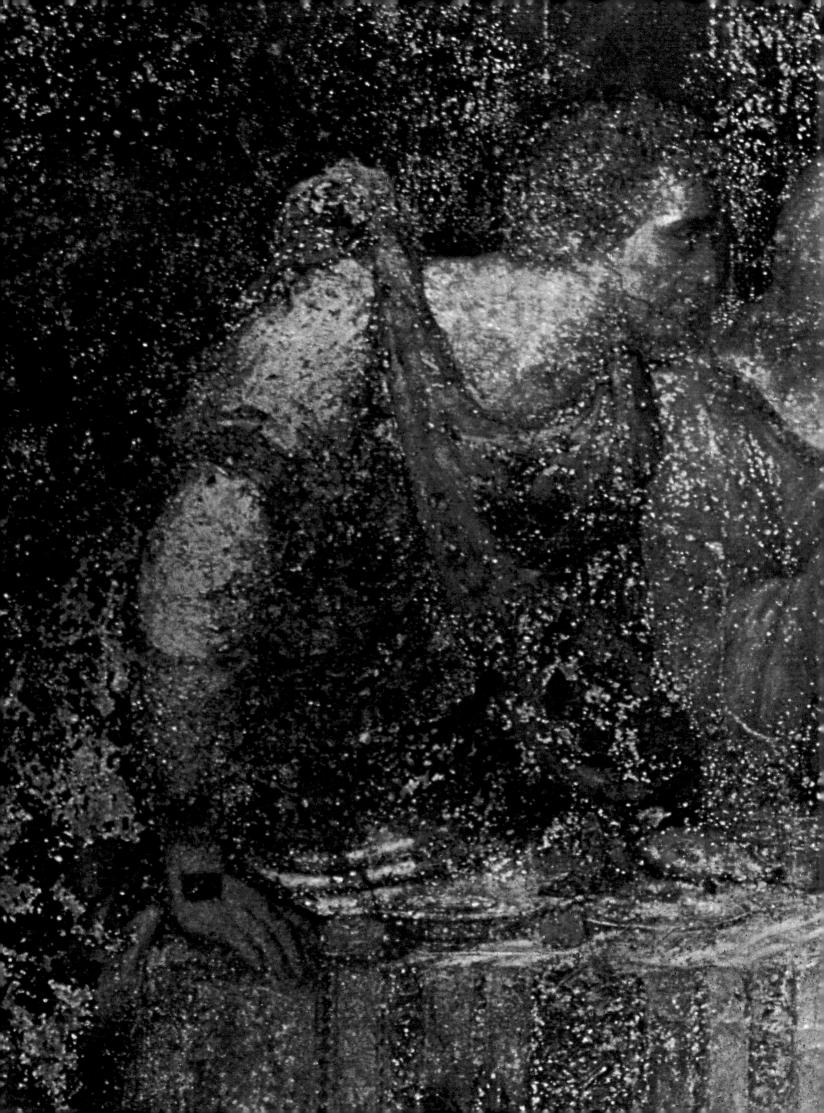

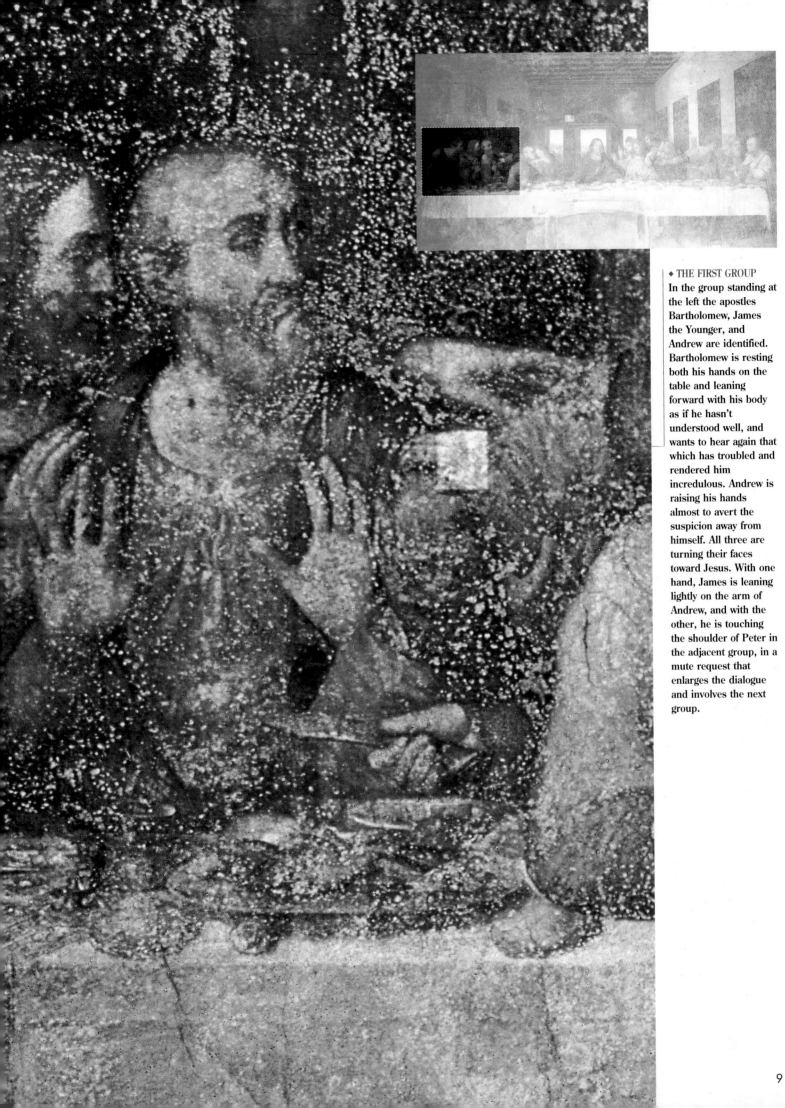

♦ THE FIRST GROUP
In the group standing at
the left the apostles
Bartholomew, James
the Younger, and
Andrew are identified.
Bartholomew is resting
both his hands on the
table and leaning
forward with his body
as if he hasn't
understood well, and
wants to hear again that
which has troubled and
rendered him
incredulous. Andrew is
raising his hands
almost to avert the
suspicion away from
himself. All three are
turning their faces
toward Jesus. With one
hand, James is leaning
lightly on the arm of
Andrew, and with the
other, he is touching
the shoulder of Peter in
the adjacent group, in a
mute request that
enlarges the dialogue
and involves the next
group.

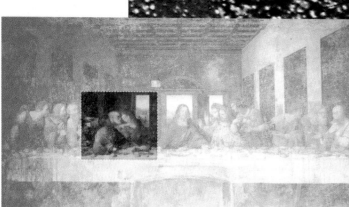

♦ THE SECOND GROUP
Here we find Judas,
Peter and John,
in a closed, pyramidal
type of composition.
With interwoven hands
placed on the table, and
a sweetly absorbed
expression on his face,
John leans toward
Peter, who is speaking
into his ear, forming
with his own body an
oblique line, parallel to
that created by the
withdrawal of Judas'
body, which thus makes
room for Peter.
Judas, stooped over,
insinuates himself
between the two.
A knife, just used to cut
food during supper,
pokes out – held in
Peter's inverted hand –
behind Judas' back.

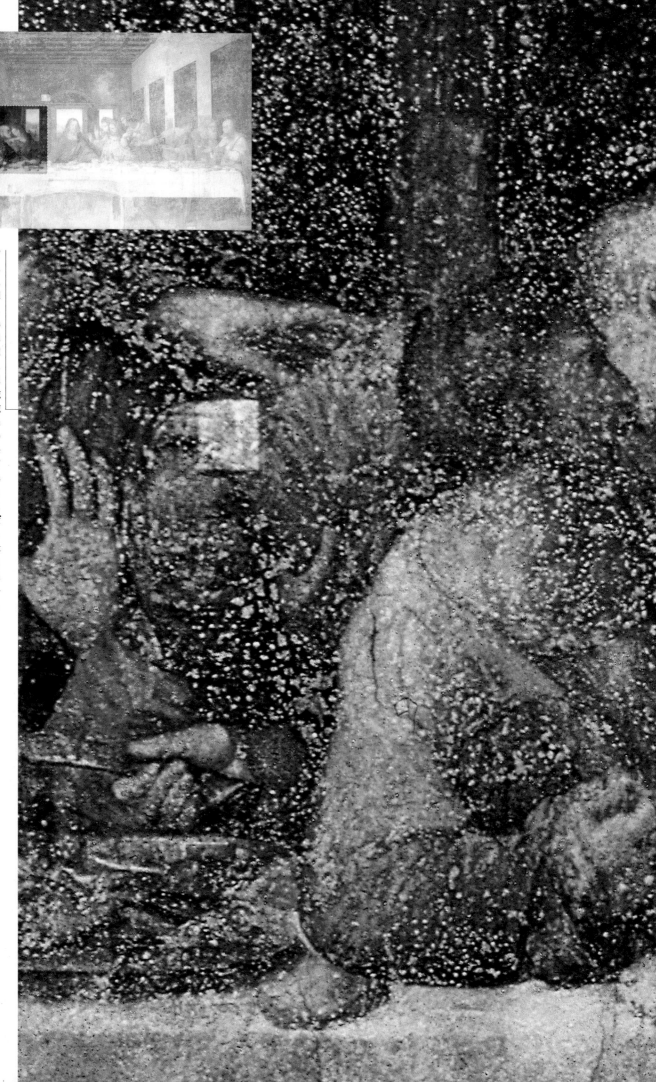

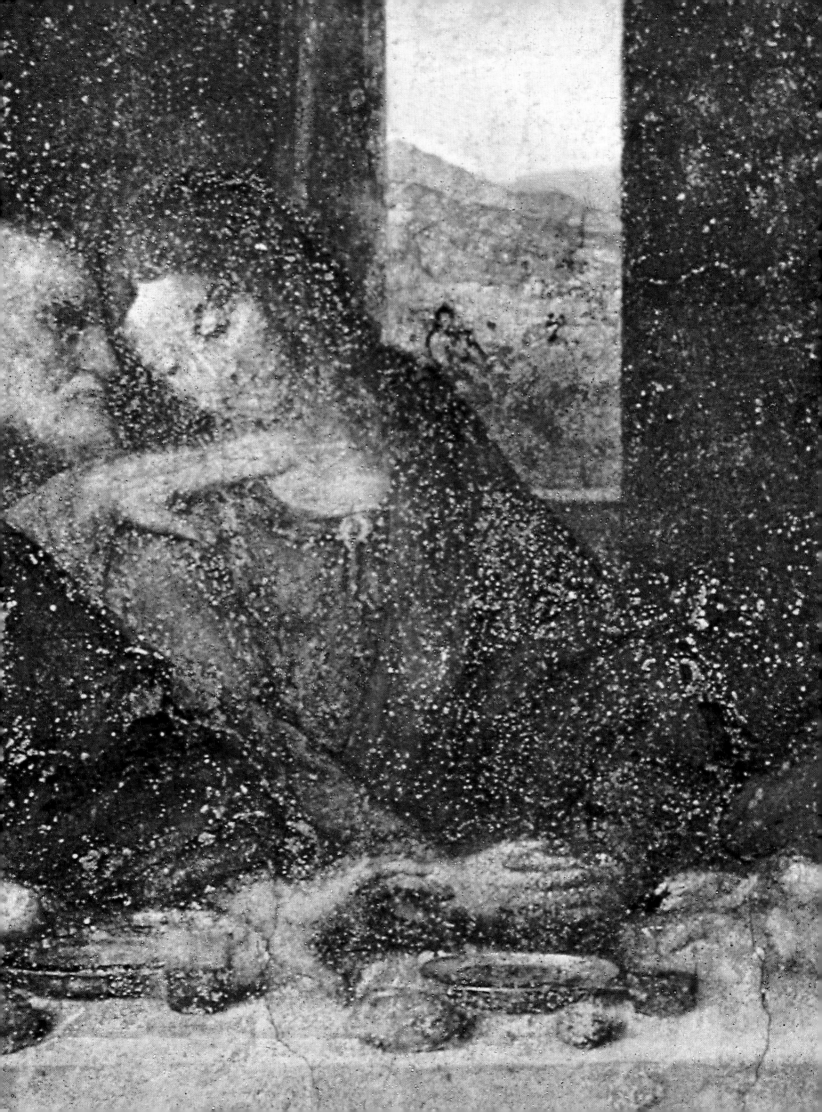

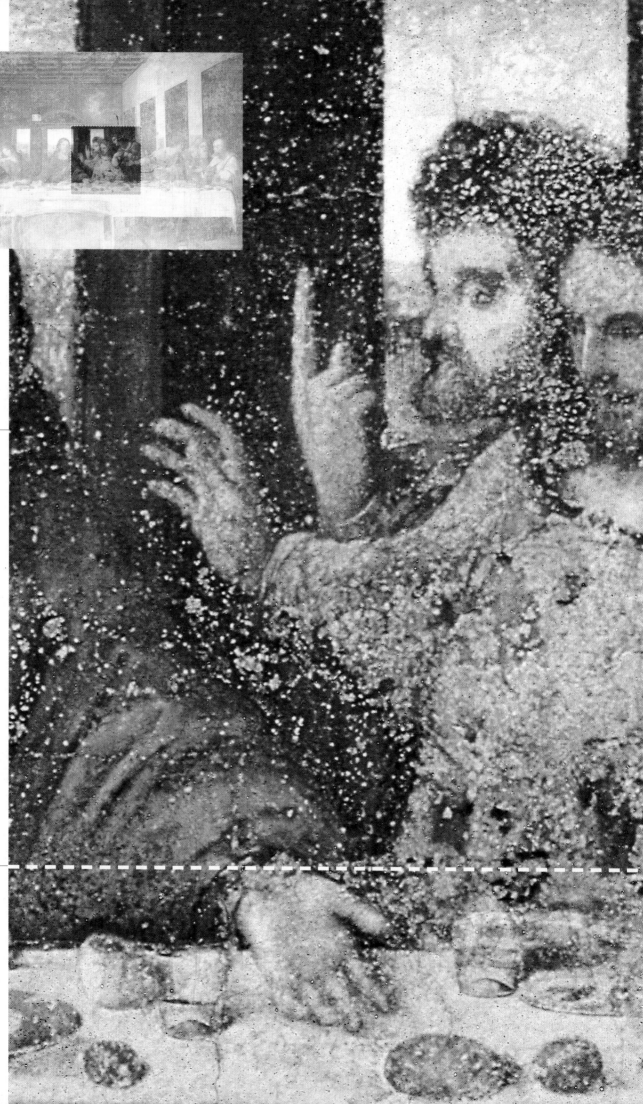

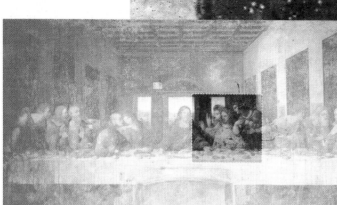

◆ THE THIRD GROUP
Even these three apostles (Thomas, James the Elder, and Philip), located to the right of Christ, form a composition that can be inscribed in a pyramid. James the Elder, at the center, spreads his arms with the manifestly sincere gesture of one having nothing to hide, offering himself to whatsoever inquiry. Behind him, to the left, an incredulous Thomas is poking out his head, with the traditional inquiring finger that sets him apart; at the right, with his figure leaning lightly forward, Philip brings his hands to his chest in a sign of innocence.

◆ THE RESTORATION
The detail indicated in the panel documents the state of the painting after the performance of the restoration. In the course of fifteen years under the direction of Pinin Brambilla, the work has proved to be complex enough, but has brought to light stunning details that have remained hidden for centuries because of dirt and because of the integrations of the last centuries. Some colors (for example the azure blue of the right sleeve of Philip, the same as that which is woven in Tuscany and in Perugia) were not perceivable before.

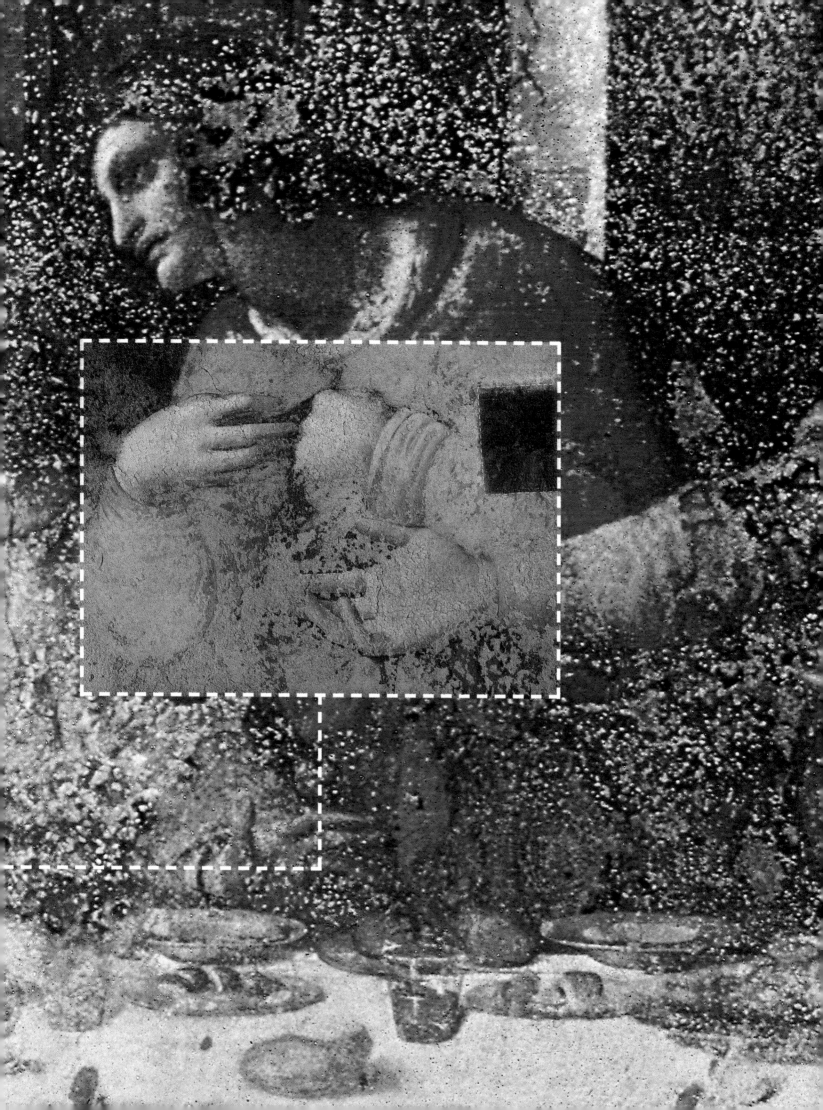

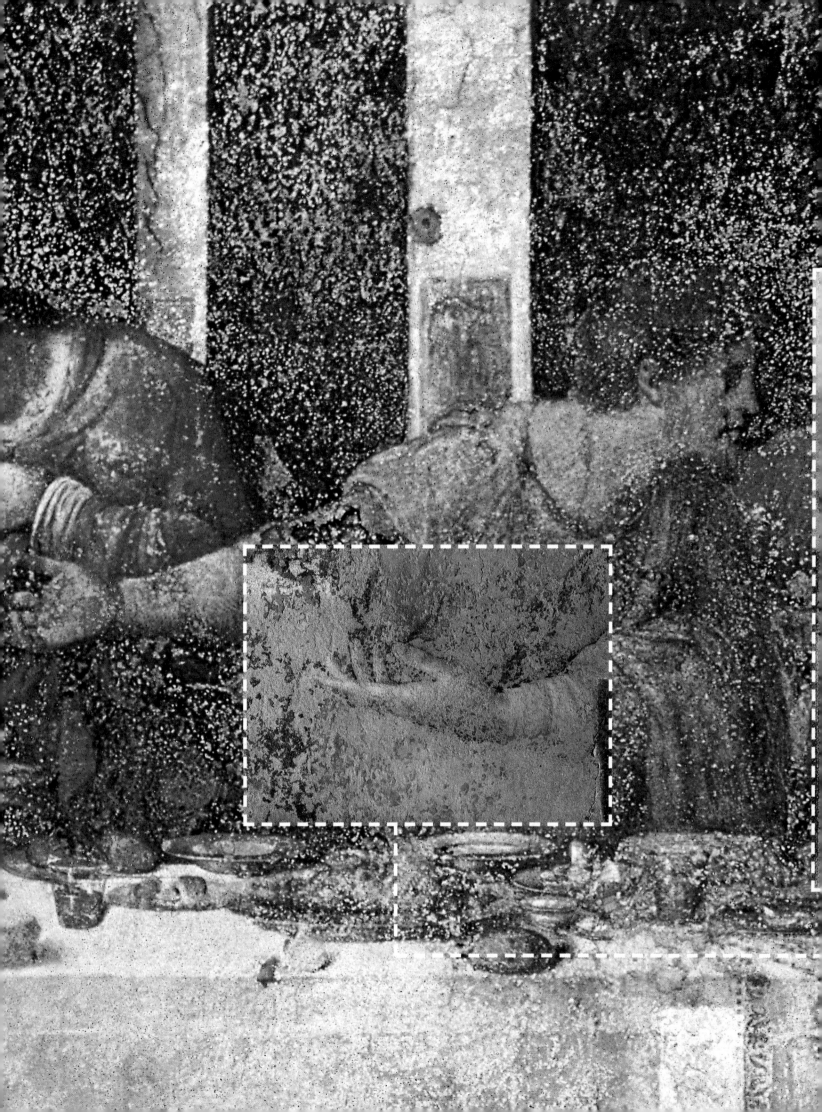

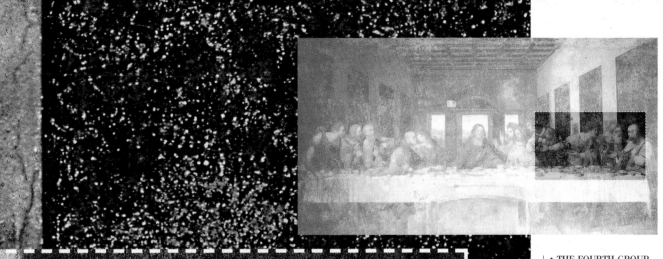

♦ THE FOURTH GROUP
Includes the apostles Matthew, Thaddeus and Simon. Matthew is pointing towards the Master with his arms and turning his face backwards toward the other two apostles, incredulous and desperate, searching for comfort in them, questioning them about what they have just heard. Here the dialogue seems to express itself almost exclusively with their hands: Simon responds by raising his hands with the palms turned upwards, confirming with his astonishment and dismay that even he has nothing to do with the matter.

♦ A NEW LIGHT
Among the surprises emerging during the restoration, the light: the faces of the apostles are now illuminated in a much more subtle way than could be seen before. Even some details of the table have taken on the prominence of a still life: the pewter plates, the wine in the glasses, the decorative patterns on the tablecloth. The restoration, of a conservative type, seeks to eliminate the damages accumulated over five centuries: the effects of infiltration of water, the repainting, and the eighteenth century attempts to keep the falling picture glued to the plaster.

UNITY OF COMPOSITION

To succeed in expressing the unitary context of a scene composed of individual factors, Leonardo needed to fill the space with a luminous atmosphere. *The Last Supper* lives on two sources of light: one, coming from the left, coincides with that actually streaming through the windows of the refectory; the other comes from the windows in the depths of the painting that open onto a luminous faraway countryside.

● Through his treatment of the light, Leonardo succeeds in creating an extraordinary unity between the illumination of the refectory and that of *The Last Supper*; but, to involve the spectator-observer in the evangelical scene, he even creates an effect of continuity between the real space of the refectory and the surface of the painting, with a sort of ideal extension. The great mathematician in him chooses a point of view coincidental with the gaze of a spectator standing in the center of the room: the illusion thus created is that of taking part in the scene. At the same time, his study of Flemish art (beginning with the great *Portinari Triptych* of Hugo Van der Goes, shown in Florence in 1478 and even today conserved in that same great city in Tuscany at the Galleria degli Uffizi) pushes him to give an extraordinary depth to the details of the represented scene.

THE PORTINARI TRIPTYCH

This masterpiece of the Flemish painter Hugo Van der Goes accelerated the process of breakdown of the old pictorial theories. The painting shows how the perspective deprives the distant objects of any distinctiveness, reducing them to pure function of composition, while the things and people in the foreground take on a particular life to which all attention must be turned. We can see the care with which the smallest details are treated in the painting of the flowers and fabrics. The triptych is composed of three panels: closed, it presents in chiaroscuro (light and shade) the figure of the *Annunciation*; open, it bears *The Adoration of the Shepherds* in the center, and on the sides, the Florentine banker Tommaso Portinari, the client, with his sons, presented by two saints; on the other side Maria Portinari with her daughter, accompanied by two saints.

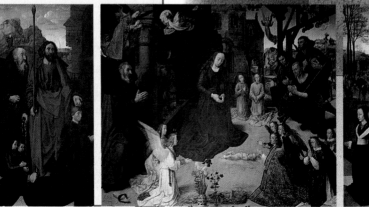

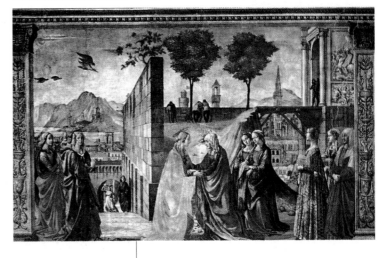

LEONARDO

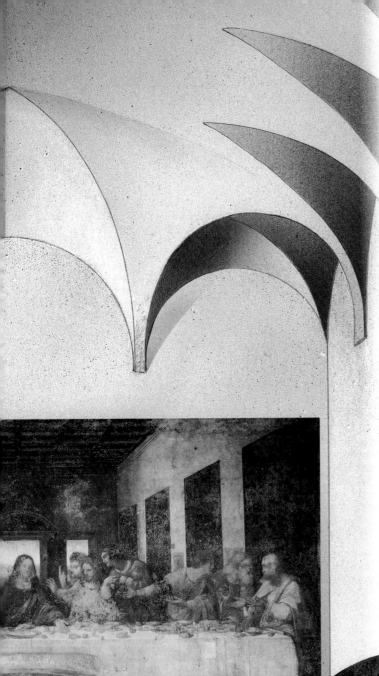

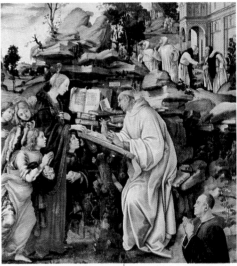

♦ **LEONARDO AND THE FLEMISH**
Leonardo carefully studied the existing works of Flemish art in Florence and Milan. Much more thoroughly than the other great artists (like Piero di Cosimo, Filippino Lippi and Ghirlandaio), he examined the meaning of forms and technical secrets of this art. Paintings such as *The Virgin of the Rocks*, below, could not have been conceived without the knowledge of Flemish painting.

♦ **DOMENICO GHIRLANDAIO**
Visitation
(1486-1490, fresco, Florence, Choir of Santa Maria Novella).
The careful Flemish study and reflection on naturalism are evident in this painting, which is part of a cycle with *History of the Virgin*. The feminine figures appear majestic and priestly in the details of both their faces and clothes, the light makes the chromatic refinement of the surface stand out and exposes the quality of the material, the landscape is no longer conventional but cared for in every detail.

♦ **THE VIRGIN OF THE ROCKS**
(1483-1508, Paris, Louvre). The study of light as present in all the particulars of the atmosphere committed Leonardo greatly to the research of the pictorial effect of delicate gradations of light and color, and so it is probable that the artist studied with much care the luminosity of the surface color of Flemish painting.

♦ **FILIPPINO LIPPI**
Apparition of the Virgin to Saint Bernard
(1484-85, Florence, Church of Badia).
The individuation of the spaces, the intense coloring, the elongated forms of the figures, and the exasperating naturalism with which Lippi treats the jagged rocks and the trunk which the saint has chosen as a lectern all constitute a net reference to the Flemish lesson.

GESTURES AND EXPRESSIONS

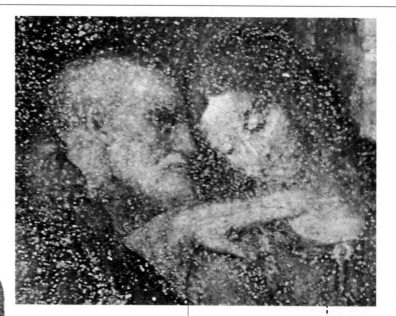

"The good painter has to paint two main things, which are man, and the conception of his mind. The first is easy, the second difficult, because it must be represented with gestures and movements of the limbs." So speaks Leonardo in *Treatise on Painting* on the importance of revealing a person's emotions and thoughts through gestures and facial expressions.

● Once again it is the scientist, the student of nature which comes to the aid of the artist and guides him in his observations, counseling him to study people – without their knowledge – while they are angry or in animated discussion or sad or expressing any emotion whatever. And so, based on his personal observations, Leonardo discards the system of norms regulating the representation of gestures and expressions, bringing it to the highest level of the French theories of the seventeenth century.

● The master thus chooses the moment of the supper most fraught with tension: every apostle is questioning himself on the possibility of betrayal, and is reacting, according to his age and character, with a different gesture. All this allows Leonardo to observe and study different reactions to the same stimulus, and to set the gesture corresponding to each emotion. Only Jesus is motionless, and expressions, looks and gestures flow towards him in a sort of theatrical staging springing forth from his solemn announcement.

◆ **AN INGENUOUS FACE**
The light illuminates the ingenuous and sweet face of the young apostle, perhaps reassured by the words of Peter, who has drawn close to him with a gesture of his hand. Peter, also in full light, is between John and Judas, the only one held deliberately in shadow.

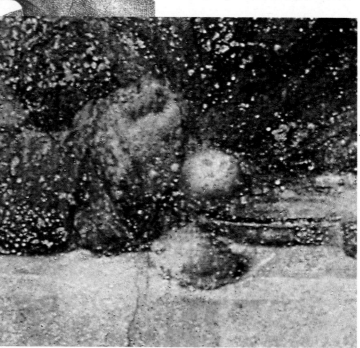

◆ **THE HOOKED HAND**
The Last Supper demonstrates the interest of the artist towards the reactions of the apostles caused by the words just pronounced by Jesus, while the tradition had iconographically fixed another moment: that in which Christ, after having dipped the bread, hands it to Judas, identifying him as the traitor. Here, differently, Judas extends his left hand to grasp rapaciously a piece of bread, while with his right tenaciously holds the sack with the thirty coins of the betrayal, almost afraid to see the price of his deed come to naught.

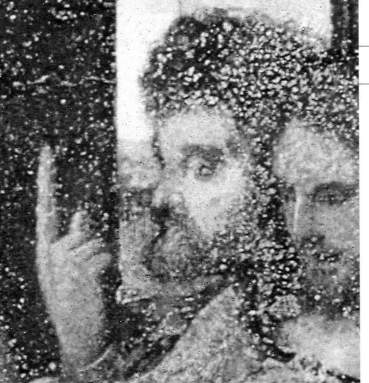

◆ THE INQUIRING FINGER
Leonardo availed himself, as is evident in this case, of the classic iconography in order to characterize persons with that system of coded gestures useful for immediately identifying their role or peculiarity. The incredulity of Thomas, his desire to know and thus touch reality with his hand, is once again entrusted to his inquiring finger.

◆ SURPRISE
The careful study of gesticulation and expression is testified to in a series of sketches and character studies through which the master observed and investigated the human spirit.

Philip's expression of surprise is already present in a study by Leonardo of the apostle's head conserved by the Royal Library of Windsor. The hands brought to the chest reinforce the expression and underline its intensity.

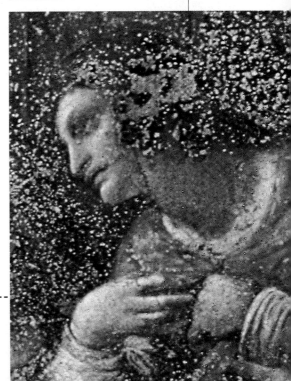

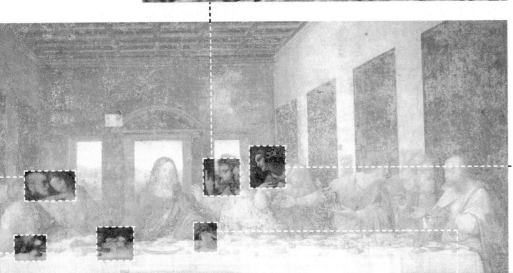

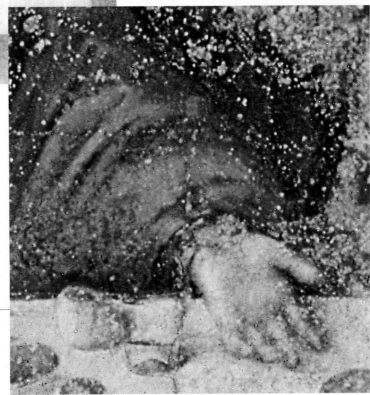

◆ EUCHARIST: THE WINE
The simple indication of the chalice symbolizes the Eucharist instituted by Jesus on exactly this occasion in the presence of the apostles.

◆ EUCHARIST: THE BREAD
With his left palm facing up, Jesus is pointing to the bread (bread and wine represent the body and the blood, offered in sacrifice). The opposite orientation of the hands indicates earth and heaven, between which the Son of God places himself for the salvation of man.

ARTIST OF SCIENCE

A doubting, critical and dogmatic spirit, Leonardo pushes himself with great passion into reality, to analyze it and discover its secret, taking every chance to study it, experience it, and know it, tolerating badly situations that constrain him to a vague estheticism or an abstract spiritualism. And so he looks for a different cultural ambience in Milan; he presents himself to the Duke (of Sforza) more as an engineer than an artist; he knows that in dynamic society inventions and technical ability count more than elsewhere. Commissions for urban layout, the realization of new canals, and military engineering connected to cartographic study and the mechanics of instruments of war are entrusted to him. Alongside these commitments there are also scenographic inventions for theatrical performances, clothing for the masques, and decorations that depict the ephemeral displays of the festivals. And so it is in the Milan of Moro, more than in the milieu of Florence, that Leonardo finds his path, and the development in all the directions that his genius wants to go.

♦ CODE OF FRANCE
At the left, original binding of the C Manuscript.

♦ SFORZA MONUMENT
Sketch for the monument to Francesco Sforza in bronze, never realized.

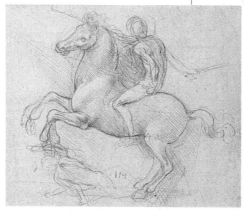

♦ DOMENICO GHIRLANDAIO
Marsilio Ficino, Landino, Poliziano and Demetrio Greco
(1486-1490, fresco, Florence, Choir of Santa Maria Novella).

THE POLITICS OF BALANCE

After the Peace of Lodi (1454), which establishes a balance between the powers being asserted in Italy, the peninsula comes to be divided into wide regional states: in the north, between the Dukedom of Savoy and the Republic of Venice, is found the Dukedom of Milan, the most powerful of the three; in the center the powerful states are the Republic of Florence and the State of the Church. The system of balance functions for forty years, and its protagonist is Lorenzo Il Magnifico (Lawrence the Great). In this period, Italian culture reaches its highest levels, through the Court of the Medici in Florence (with people such as Marsilio Ficino and Angelo Poliziano), and the Sforza in Milan, focusing itself in academies, retreats for scholars and intellectuals, who prefer to meet outside the universities, which are still too tied to the old medieval knowledge.

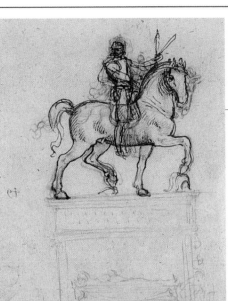

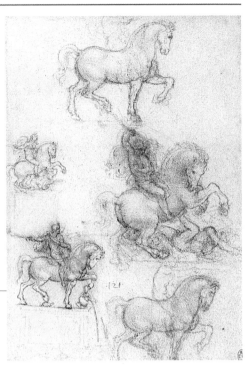

◆ THE TRIVULZIO MONUMENT
Leonardo's designs for the equestrian monument to Gian Giacomo Trivulzio are dated between 1508 and 1512. The illustrious commander in the service of the French was Governor of Milan and Marshal of France.

◆ STUDIES FOR AN EQUESTRIAN MONUMENT
This monument, planned for the sepulchre of the Marshal of France, was also never realized. There remain these designs of an idea that was much cherished by Leonardo from the time of his association with the studio of Verrocchio.

◆ SALA DELLE ASSE (Milan, Sforza Castle). Leonardo transformed the walls and ceiling of the room into an extraordinary arbor. A complex interlacement of knotted cords, branches and leaves, with heraldic reference to Moro-jasmine and the Vinci goes from floor to ceiling. Leonardo studied the theme of the interlacement, painted later by Albrecht Dürer, in the files of the Vincian Academy.

◆ ANDREA DEL VERROCCHIO
Monument to Colleoni
(1488, Venice, The Field of Saints John and Paul). The monument exudes great strength and pride. Four meters (thirteen feet) high, it forms, together with the Gattamelata of Donatello, a point of reference for Leonardo in making the model for the Sforza monument.

THE GENIUS AND THE ARTIST

ART AND POLITICS

Various hypotheses have been formulated on what sent Leonardo away from Florence. Not last is an accusation of sodomy, which would have involved him in a scandal. But it is more probable that the Medici – who were using Florentine art and culture as ambassadors of the cultural power of Florence to the whole of Italy and to consolidate economic and political relations – used him as an element of negotiations in a political matter.
A similar thing occurred in Rome in 1481-82, after

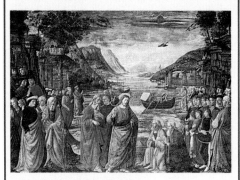

◆ DOMENICO GHIRLANDAIO
The Vocation of Peter and Andrew
(1481, Rome, Sistine Chapel).

the conspiracy of the Pazzi. In that case peace came by the substitution of the workers used for the decoration of the Sistine Chapel: the Perugian artists were sent away, and those from Florence (Ghirlandaio, Botticelli, Biagio d'Antonio, Cosimo Rosselli, Piero di Cosimo, etc.) were called. In that same period also other artists from the Florentine culture were sent by the courts: Andrea del Verrocchio to Venice for the equestrian monument to Bartolomeo Colleoni, Biagio di Antonio to Faenza care of the court of the Manfredi.

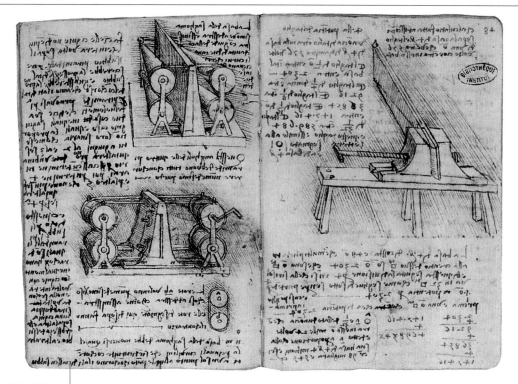

◆ BURNING GLASSES
The studies of mathematics, optics, and mechanics are at the base of the construction project for a machine for grinding concave mirrors.
On the same page, calculations on the power of concentration of rays of light.

◆ THE SYSTEM OF LOCKS
The *Atlantic Codex* contains a rich documentation on the knowledge of Leonardo. Here we have an example of the technological heights he reached in the field of hydraulic engineering:

in fact it is dealing with a machine for the raising of water, used in the construction of locks. We know of Leonardo's commitment to the rationalization of a system of navigable canals for the transport of goods, so much supported by the Duke of Milan.

◆ MAPS AND A BIRD'S EYE VIEW OF THE CITY OF MILAN
(1509 ca., Milan, *Atlantic Codex*). In the study of the urban structure of the city can be read – starting from high above the center, Porta Comasina – all the directional indicators from the gates of access to the city.

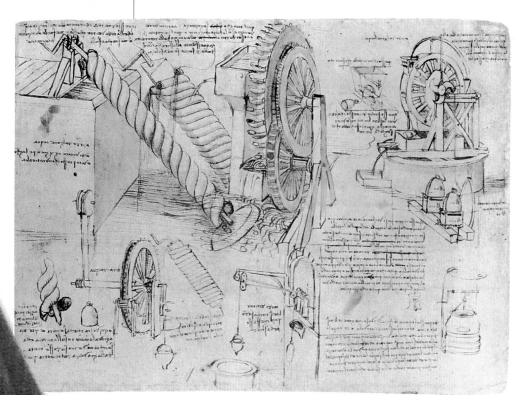

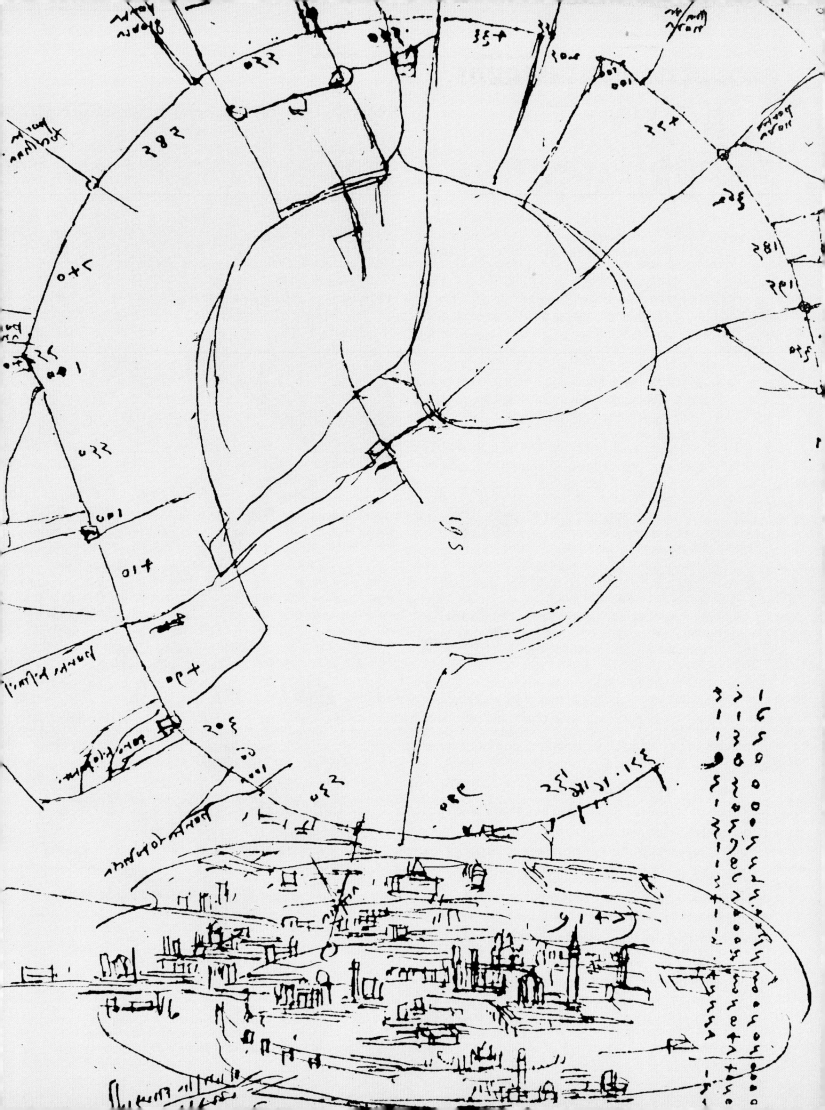

A BOLD EXPERIMENT

Leonardo was a great experimenter, and his infinite curiosity also turned toward pictorial technique. Evidently he held that the classical fresco technique – which demanded a very rapid execution time – was not adapted to rendering his formal world, especially that nuanced, delicate chiaroscuro (light and shade) in which the figure blends with the surrounding atmosphere. The need to be able to return to the figures – to modify gestures and expressions as the groups enter into relation with

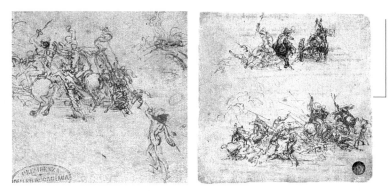

◆ DETAILED STUDIES
Two studies in pen and ink (1503-1504, Venice, Gallery of the Academy), show, on the left, the *Battle for the Standard,* **and, on the right,** *Two skirmishes between Knights and Footsoldiers*: **both are preparatory designs for the** *Battle of Anghiari.*

each other and the scene becomes more dynamic – pushes him to try new techniques in *The Last Supper,* with organic binders to fix the color on the wall, which then prove vulnerable to injury from time, humidity and atmospheric agents.

● Of another work, the *Battle of Anghiari,* commissioned in 1504 by the Republic of Florence for the Great Council Room in the Vecchio Palace, and conceived by Leonardo as a sort of natural phenomenon, between whirlwinds of smoke and dust, there are only partial copies, probably made from the preparatory drawings. The theme was supposed to commemorate the Florentine victory over the Milanese in 1440. We know that the paint began to run down the wall, because Leonardo's experimental oils and solvents couldn't withstand the heat of the braziers placed in the room to dry the picture. By 1563 the fresco was already lost.

◆ SCAFFOLDING
Leonardo had a special scaffolding built that could be raised or lowered by the use of a double-threaded screw, according to the needs of an artist committed to painting a wall of vast proportions.

◆ PETER PAUL RUBENS
Battle of Anghiari
(Paris, Louvre).
A copy of Leonardo's
drawing of the central
episode in the battle
for the standard.

◆ DORIA PAINTING
(Beginning of 16th
century, Munich, Alte
Pinakothek). This is the
most important copy of
the *Battle of Anghiari*,
done perhaps by an
artist from Tuscany in
the 16th century.

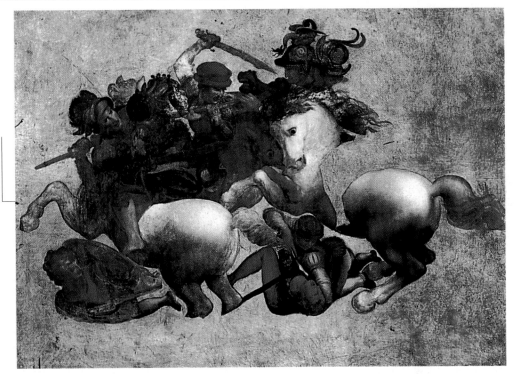

◆ MICHELANGELO
Battle of Cascina
(Florence, Uffizi
Gallery). A study in the
nude for the *Battle of
Cascina*, a battle of 1364
between Pisans and
Florentines, who,
surprised while bathing
in the Arno river, found
the strength to fight and
win.

SCHOOL OF THE WORLD

While Leonardo is working on the drawings for the *Battle of Anghiari*, the young Michelangelo also receives the commission to paint the other half of the wall with a picture of an analogous subject: the *Battle of Cascina*.
It is the chance to be able to admire the work of two greats. But the work remains in the state of preparation when Michelangelo leaves for Rome. Thus, they disappear, these works that

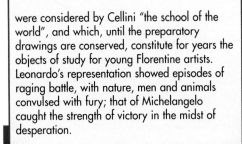

were considered by Cellini "the school of the world", and which, until the preparatory drawings are conserved, constitute for years the objects of study for young Florentine artists. Leonardo's representation showed episodes of raging battle, with nature, men and animals convulsed with fury; that of Michelangelo caught the strength of victory in the midst of desperation.

BETWEEN SCIENCE AND NATURE

Leonardo always had multiple interests in nature: from the form of clouds to the aerial view of landscapes, from the study of human and animal anatomy to that of botany. These are testified to by a great quantity of drawings grouped together over time in various collections (*Atlantic Codex, Windsor Collection, Hammer Codex, Arundel Codex,* and *Codices of Madrid,* etc.). The drawings, done with his left hand (Leonardo was left-handed, and his writing, which runs from right to left, is read more easily in front of a mirror), are incredibly acute observations, described by words on the one hand sure of himself (the "claw of a lion"), on the other hand extremely delicate. Some of these are even puzzles, "doodles", others – in par-

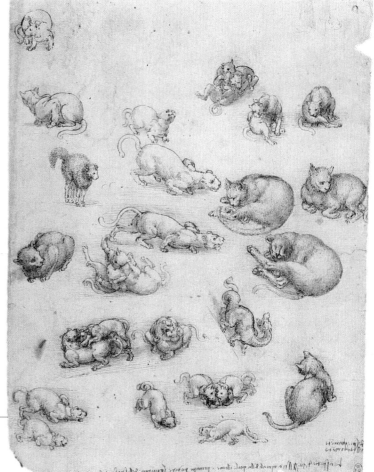

◆ STUDY OF CATS (*Windsor Collection*). These were probably done during the first period in Florence, while on a project of a *Madonna with a Cat,* perhaps never painted, but noted through various sketches.

ticular the caricatures – bring to light the playful aspect of the artist. The last ones, from his French period, are pushed to arrive beyond the physical dimension of reality, seeking to represent the invisible, that is, the energy inherent within the elements, through the traces left behind by an object in movement.

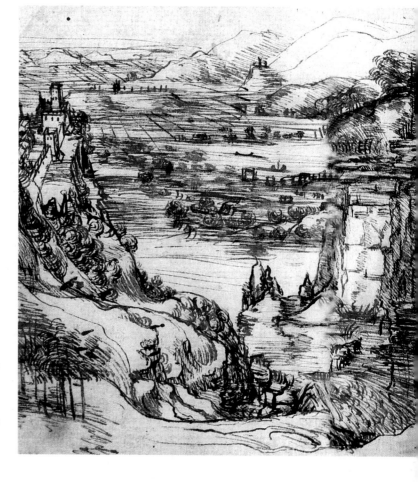

◆ THE FLIGHT OF BIRDS (1500-1505, Turin, Royal Library, *Codex on the Flight of Birds*). The careful study of the function and mechanism of the beating of wings while taking off, flying or landing brought Leonardo to the fantastic project of construction of a flying machine.

♦ BOTANICAL STUDIES
(1487-89, Paris,
Manuscript B).
Fruits and vegetables
on a great inkstain.

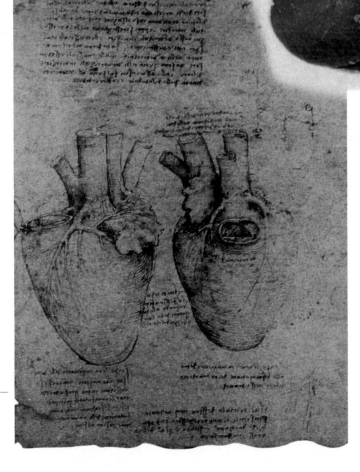

♦ LANDSCAPE WITH THE
ARNO RIVER VALLEY
(1473, Florence, Uffizi).
The novelty of
Leonardo's observations
is already revealing
itself in this early
drawing: reality comes
to be defined through
a modulation of lines
from which the objects
emerge according
to how they interact
with the light and the
vapor in the air.
The atmosphere actually
has the property to
continually change the
perception of the things.

♦ ANATOMICAL STUDIES
(1513 ca., *Windsor
Collection*). For thirty
years Leonardo
conducted studies on the
human body, dissecting
dozens of cadavers.
Extraordinarily
accurate, the drawings
remain unsurpassed
in their class.

THE FEMININE FIGURE

The portrait of Mona Lisa of Giocondo, perhaps the most famous painting of all time, has reached us in rather good condition, save the fact that in the 17th century two architectural elements were cut from the sides, probably two columns. The painting was very successful in Florence, so much so that the pattern of the columns was used in many paintings done in those years. Today the work is dimmed by a blanket of dirt and paint which renders it hardly legible. If it is examined under a strong, direct light, we realize that it is very clear, with a landscape of distant mountains whose tops are covered with snow, and that above all it is not damaged: there are just some rather wide cracks in the color, especially on the neck.

● This shows us that the painting was done with a mixed technique of tempera and oil. Very often, oil on tempera leads to that wide cracking, which has been hidden by some retouching. Cleaned, it would be completely different: but the immense mystery that surrounds *The Mona Lisa*, owing especially to this blanket of dirt and paint, would be lost. Sometimes works of art give rise to infinite suggestions precisely because of their state of conservation.

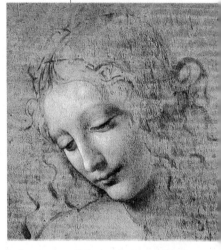

◆ LA SCAPIGLIATA (THE DISHEVELED WOMAN) (1508 ca., Parma, National Picture Gallery). Below, a beautiful little painting depicts a "disheveled woman", mentioned in the Gonzaga inventory, drawn with pen and heightened in part.

The attraction of *The Mona Lisa* is inexpressible, with just a hint of a smile, and an expression between irony and resignation.

● *The Mona Lisa* and other earlier portraits demonstrate how Leonardo represented feminine models of a particular type: the rational woman, sure of herself, conscious of her own personality, master of her own thoughts and actions.

● The beautiful *Portrait of a Woman*, depicting the melancholy Ginevra Benci, belongs to his early period in Florence. The warm tones contrast with the pallor of the face framed with rich, ginger hair. In Milan he paints two extraordinary portraits alive with light: the so-called *Belle Ferronnière* and the stupendous *Lady with the Ermine*. Both were perhaps lovers of Ludovico Il Moro: the former is almost surely Lucrezia Crivelli, the latter Cecilia Gallerani (the rebus is provided by the Greek word for ermine, "gale", which recalls the woman's name). The echo of Flemish painting (Rogier Van der Weyden, Hugo Van der Goes, and even more Hans Memling) is felt above all in the former painting.

◆ LADY WITH THE ERMINE (1485-90, Krakow, Czartoryski Museum). Cecilia Gallerani, favorite of the Duke, holds in her arms an ermine, symbol of nobility and emblem of the order conferred on Ludovico Sforza by the King of Naples in 1489. Illuminated by a strong source of light, the young woman is presented foreshortened.

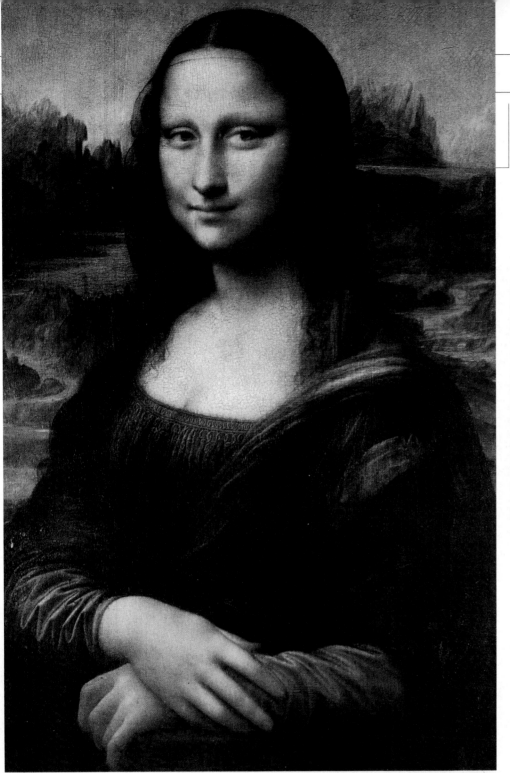

♦ THE MONA LISA (LA GIOCONDA) (1503-1506, Paris, Louvre). It is absolutely the most famous work of Leonardo in all the world, noted above all for its ineffable smile and the mysterious gaze that have caused so many to dream, suggesting and stimulating a thousand interpretive hypotheses. According to a recent critical reading, the lady would represent Chastity, who dominates and wins over Time, with a delicious smile of triumph.

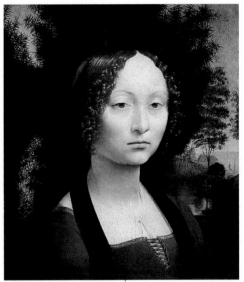

♦ LA BELLE FERRONNIERE (1495 ca., Paris, Louvre). The name is derived from an improper 17th century cataloguing which recognized her as the lover of Francesco I, wife of an "blacksmith"; elsewhere, she is cited as the Duchess of Mantova. The intensity of her gaze, the same "craquelure" of *The Mona Lisa*, identify it as a certain work of Leonardo.

♦ PORTRAIT OF A WOMAN (1473-75 ca., Washington, National Gallery). The wood is painted even on the back, bearing a scroll with the motto "Virtutem forma decorat" that wraps around a sprig of juniper. Juniper, which alludes to the name of the woman (Ginevra Benci), forms a corona for her. The only known portrait from the first Florentine period.

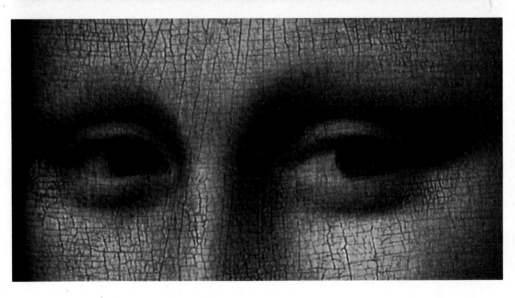

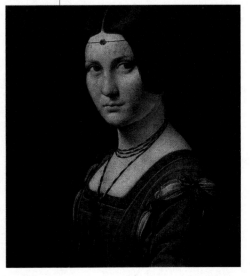

THE VIRGINS

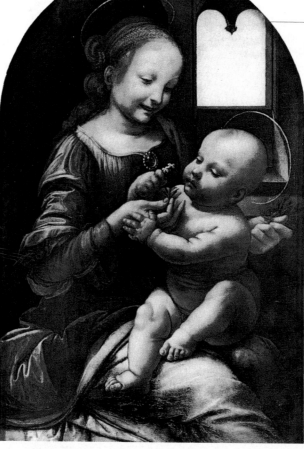

In a note by Leonardo written in the margin of a design conserved at the Uffizi we find a reference to "two Virgin Marys" begun in 1478, which are probably the *Benois Madonna* of Saint Petersburg and the *Madonna with the Carnation* of Munich. These early works do not elude the influence of Verrocchio, as is also true with the *Madonna with the Cat*, known by drawings from Florence and Bayonne. Another, the *Madonna with the Carafe*, is described by Vasari, who saw it in the collection of Pope Clement VII.

● From a letter to Isabella d'Este from Brother Peter of Novellara, we learn of a *Madonna dei fusi*, painted by Leonardo for Florimund Robertet, secretary to Louis XII, of which some preparatory studies and at least two versions are known, which the critics attribute to the hand of Leonardo (especially that of New York).

● These works – as well as the youthful and lovely *Annunciation*, the two versions each of the *Virgin of the Rocks* and *Saint Anne*, the *Madonna and the Child*, the *Litta Madonna* and still others – and the portraits of women, show us with what care Leonardo approached the feminine figure in general, and that of the Virgin in particular, containing the mystery of maternity and the divine in the veiled and just-hinted smiles, and in the chiaroscuro (light and shade) softness that wraps up the Incarnation.

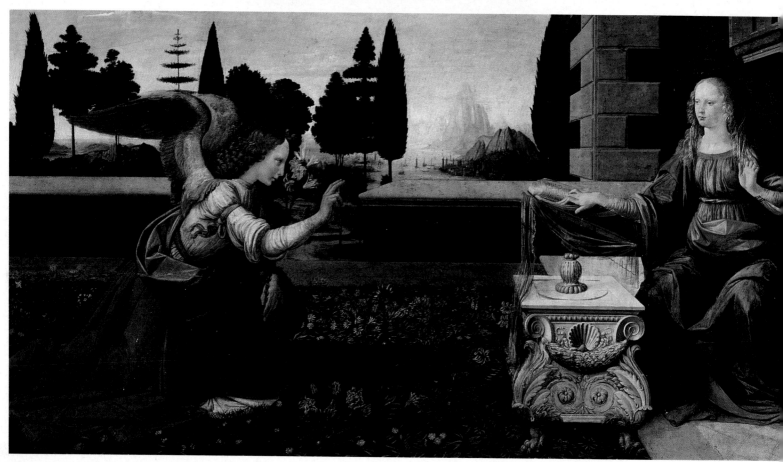

◆ BENOIS MADONNA
(1478-80, Saint
Petersburg, Ermitage).
With an amused and
loving expression, the
mother holds her son in
her arms. The dynamic
rotation suggests
a three-dimensional
spatiality.

◆ LITTA MADONNA
(1478-80, Saint
Petersburg, Ermitage).
Born from an ideation
of Leonardo, it is held
by now by the major
part of critics to be a
notable elaboration
of his studio.

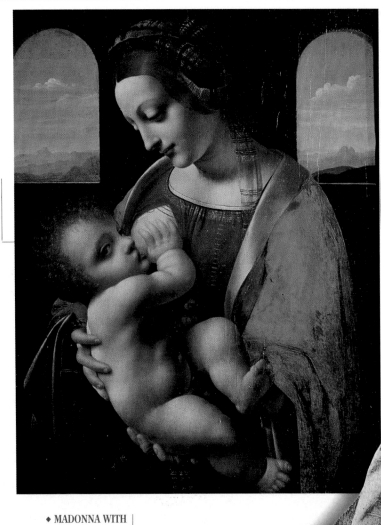

◆ ANNUNCIATION
(1470-75, Florence,
Uffizi). This tempera
and oil carries the signs
of the collective
intervention of the
studio of Verrocchio.
The innovations are the
backlit trees in the
background, and the
draping that underlines
the anatomical forms.

◆ MADONNA WITH
THE CARNATION
(1478 ca., Munich,
Alte Pinakothek).
Even this resounds
with the influence of
Verrocchio, above
all in the hairstyle
of the Madonna
and in the vase
of flowers.
But the yellow
notation of the
mantle, the clear
blue of the body,
and the landscape
laden with vapor
that shades in
chromatic gradations
towards infinity are
clearly Leonardo's
inventions.

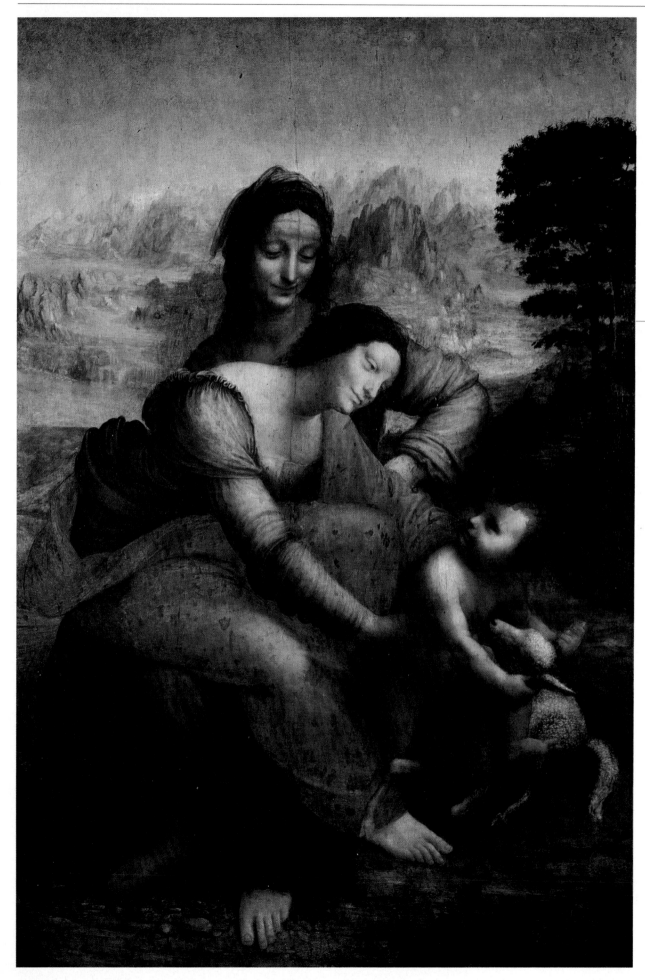

◆ SAINT ANNE, THE MADONNA AND CHILD, WITH THE LAMB (1510, Paris, Louvre). The pyramidal structure is made dynamic by the gesture that connects the Virgin and Child. The affectionate atmosphere dominating the piece still closely relates to the environment. In the painting, the expressive force of Saint Anne's gaze is lost.

◆ SAINT ANNE, THE MADONNA, THE CHILD AND THE YOUNG SAINT JOHN (1508, London, National Gallery). All the Christian sacredness is contained in the gesture of Saint Anne pointing upwards, saying that all happens for the Will of God. Mary, seated on the knee of Saint Anne, is holding back her son, who is leaning toward the young Saint John.

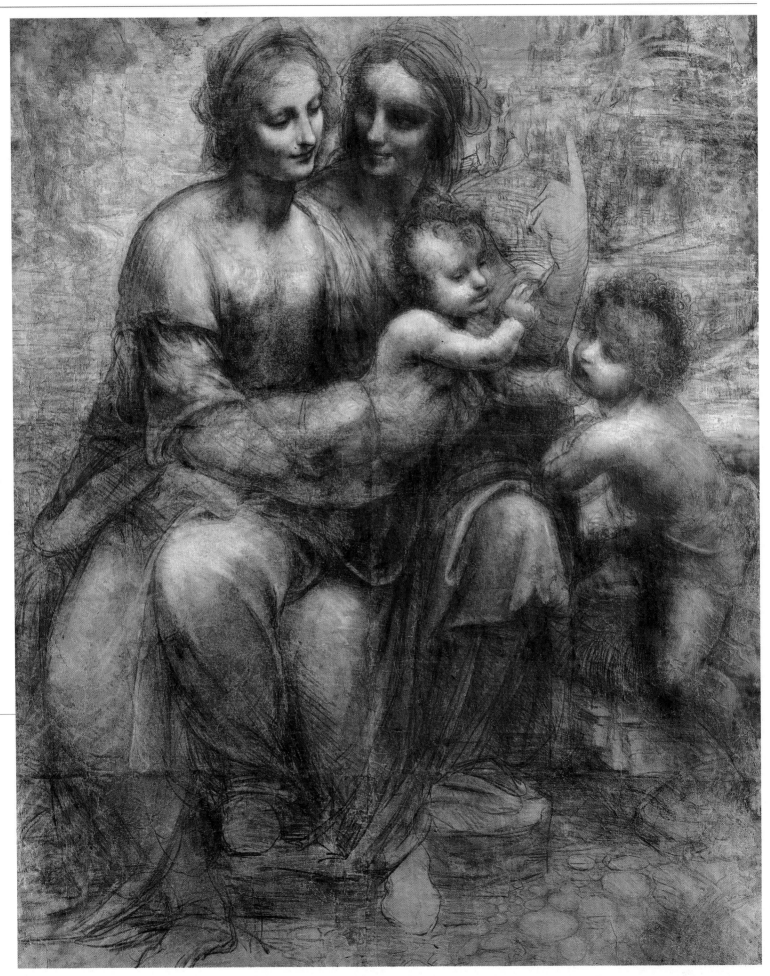

THE TREATISE ON PAINTING

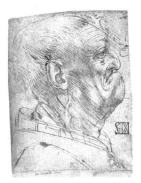

Considered among the most precious documents in the history of art, Leonardo's *Treatise on Painting* is known to us through the manuscript of Francesco Melzi, from about the middle of the 16th century, and another forty or so manuscripts that copy it in part. The first French edition of the treatise is important, published in 1651 with the drawings of Nicholas Poussin.

● On many occasions Leonardo expressed his faith in the experimental means of painting, for him a definite science, being based on mathematical perspective and the study of nature.

● His observations on the relationship between light and shade, and on aerial perspective, are extraordinary: a correct distribution of light and shade gives the painting the appearance of relief, just as the atmosphere shades the contours of more distant objects and alters their color. In his work, in fact, distant hills appear blue.

● Leonardo thinks little of having his figures conform to an absolute canon of harmony: what interests him more is their authenticity and characteric, as is seen in the caricatures of his sketch album.

● The representation of man, therefore, does not consist of solely drawing the body, but also the spirit, revealing its thoughts and emotions through gestures and expressions. According to the theory of propriety, the gestures must express feelings in relationship to the age, rank and role of the person.

♦ MEN'S HEADS
A series of studies reveals Leonardo's interest in the portrait, but also his ability to read his subjects' ludicrous characteristics.

♦ VITRUVIAN MAN
(1490 ca., Venice, Gallery of the Academy). Leonardo takes the measure of the "well-figured" man from the text of Vitruvius: standing, with arms and legs extended, he can be inscribed perfectly in a circle (whose center is the navel), and in a square (whose center falls at the top of the genitals).

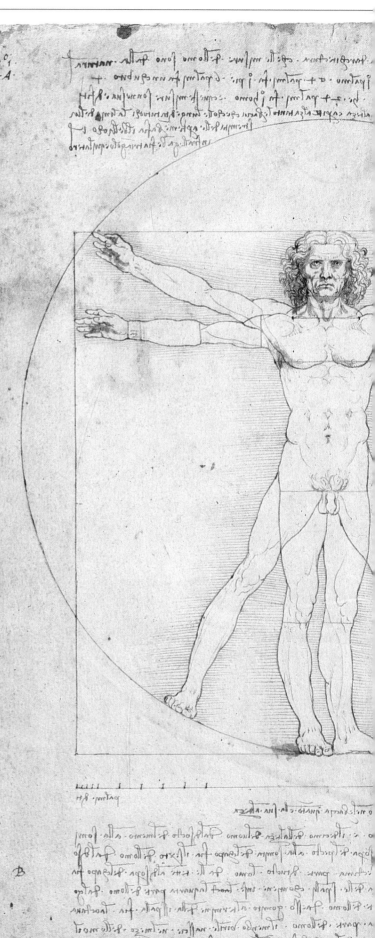

♦ BLUE MOUNTAINS
Mountainous, distant, and mysterious landscapes are evoked in the depths of many paintings. In the *Madonna with the Carantion* conserved at the Alte Pinakothek of Munich, the landscape bursts in luminously from the double mullioned windows placed in a dark wall. The mountains and sky are based in a subtle atmosphere, which turns all the distant objects blue.

♦ AN INFINITE LANDSCAPE
Foreshortening of landscapes that fade away into the infinite are perhaps more responsible than any other thing for suggesting the supernatural dimension in the paintings of sacred subjects. As in this case, in which the composition with *Saint Anne, the Madonna and Child, with the Lamb* (Paris, Louvre), represents the relationship between earthly and divine love.

♦ STUDIES ON MOTION
Leonardo searched long and feverishly in his drawings for the way to reproduce the movement of bodies, their dynamism, noting in the margins the rules connected to the device. But the superbly high figurative quality of his studies prevails over his theories, as with this horse breaking into an unbridled gallop, a study for a detail of the *Battle of Anghiari*.

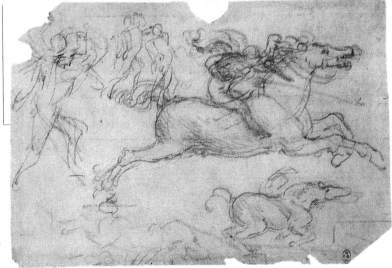

AN ENDLESS RESEARCH

Always taken by new interests, Leonardo has difficulty in bringing his works to a conclusion. The Brothers of the San Donato a Scopeto monastery in Florence commission him to paint the altarpiece *Adoration of the Magi* in 1481, which never gets finished because of Leonardo's departure for Milan. The work, today at the Uffizi, is only a sketch in pen and ink, never colored. The picture is an altogether new composition, particularly bold for that age: the figures who participate in the extraordinary event coronate the Virgin, stretching themselves in an orbital movement toward the slender figure who is immersed in an atmosphere that is also an invisible barrier to the masses of people.

● *Saint Jerome* in the Vatican Picture Gallery is also unfinished: but the lack of color takes nothing away from the structural drama. Here also, as in the *Virgin of the Rocks*, a distant landscape of bluish mountains opens in the background, against which is silhouetted the saint's figure, hollowed out by his suffering.

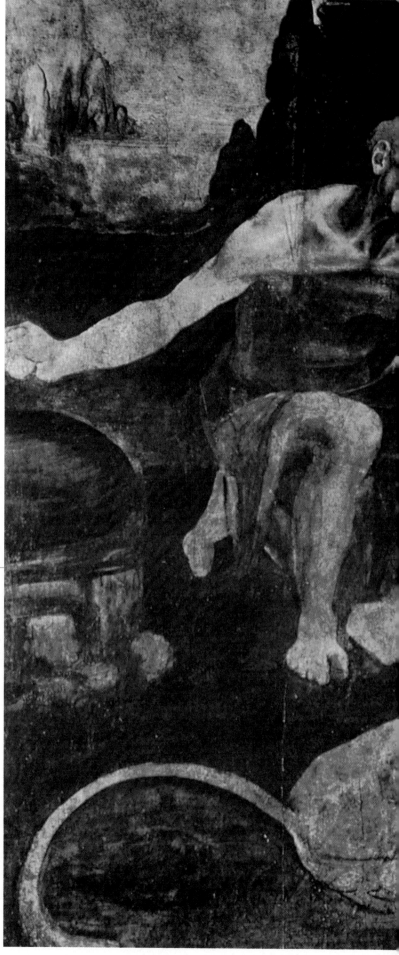

◆ THE FACADE OF A CHURCH
The drawing of a church is unpredictably inserted in an upper corner of the painting.

◆ SAINT JEROME (1482 ca., Rome, Vatican Picture Gallery). The monochrome of the unfinished painting takes nothing away from the anatomical construction of the figure of the saint, perfectly inscribable in a triangle, which with difficulty contains his suffering.

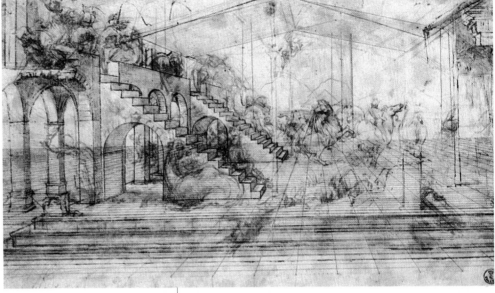

◆ **PERSPECTIVE STUDY FOR THE ADORATION OF THE MAGI** (1481 ca., Florence, Uffizi, Cabinet of Prints). The format follows the rules of linear perspective. The ruins of an antique architecture, which will be present in the painting, demonstrate the relationship between a pagan world and the beginning of a new age. Meanwhile, the dominant perspective and the centrality of the great cabin disappear in the defined version.

◆ **ADORATION OF THE MAGI** (1482, Florence, Uffizi). The composition, thought out at length, as evidenced by a series of preparatory drawings, appears to have revolutionized the subject, with respect to classical iconography. The Madonna and Child are the hub of the scene around which turn the adoring onlookers, set in a semicircle. There is no herald angel, no comet, and no sumptuous arrival of the Magi from the distant Orient.

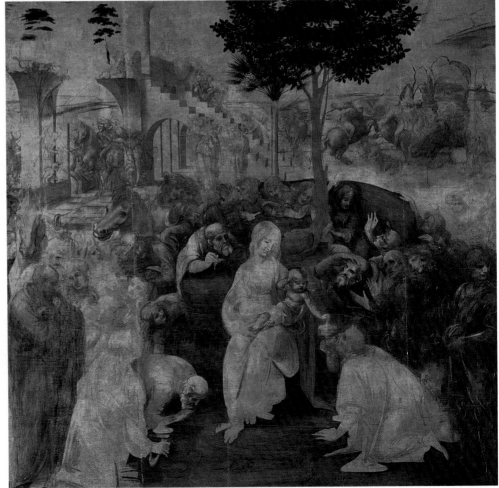

GRACE AND PERFECTION

Leonardo's Florentine apprenticeship care of the studio of the painter and sculptor Andrea del Verrocchio takes place between 1467 and 1478, while Lorenzo de' Medici is Prince of Florence. In the circle of the Court of the Medici can be delineated the neo-platonic philosophical current characterized by the personalities Pico della Mirandola and Marsilio Ficino. The poet and humanist Angelo Poliziano is writing the *Fable of Orpheus,* performed shortly

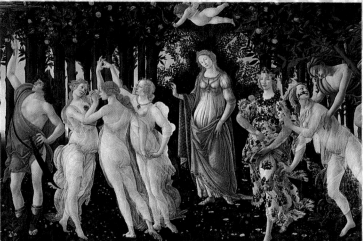

thereafter with Leonard's scenography. Leonardo and Botticelli meet in the studio of Verrocchio, the youngest and the oldest of his students, destined for a long hostility.

● In 1478 the masterpiece of the Flemish painter Hugo Van der Goes, *The Portinari Triptych*, arrives in Florence, while Filippino Lippi is dedicated to finishing the work of Masaccio in the Brancacci Chapel, Botticelli is painting *Primavera* (*Spring*), and Piero di Cosimo is making landscapes dissolve into transparency and distant vapors.

● From 1480, Ludovico Sforza, called the Moro, is Prince of Milan. Leonardo is in the city from 1482 to 1499, where he comes to know Bramante. It is significant that in Leonardo's designs in this period recur studies of centrally

planned buildings with apsidal bodies coordinated with a central dome, a theme which Bramante deals with in his work in Milan, and later in the project for the reconstruction of Saint Peter's Basilica.

● These are the years of the Italian Wars (1494-1559). With the descent of Charles VIII from France begin the foreign invasions of the Italian peninsula and opens a long period of struggles between France and Spain for its political and military control, coinciding, moreover, with an exceptional flourishing of culture that comes to be considered the climax of the Renaissance.

● In 1499, with the fall of the Moro and the arrival of the French, Leonardo leaves Milan and turns first to Mantova – where he comes into contact with the work of Andrea Mantegna at the Court of the Gonzaga family – and then to Venice. Finally he returns to Florence, which has meanwhile, in 1498, put Savonarola to the stake, and from which Leonardo once again leaves for Urbino and Romagna in the footsteps of Cesare Borgia. In just this period Machiavelli is sent from the Republic of Florence on a diplomatic mission to Cesare Borgia, the Duke of Valencia.

◆ SANDRO BOTTICELLI
Primavera
(1482 ca., Florence, Uffizi). Botticelli was the object of Leonardo's criticism for his "gloomy landscapes".

◆ DONATO BRAMANTE
Tempietto of Saint Peter in Montorio (1502, Rome). Leonardo held Bramante, with whom he worked at Santa Maria delle Grazie, in high esteem.

♦ ANDREA MANTEGNA Fresco in the Camera degli Sposi (1473 ca., Mantova, Ducal Palace, eye of the ceiling). Isabella d'Este of Mantova becomes an essential reference for Leonardo, who goes to see her when he leaves Milan in 1499. Here he has the chance to admire the bold architectural illusion conceived by Mantegna. In 1502 Leonardo is in Florence, but he is working for the princes of Mantova, the Gonzaga family, and for the French.

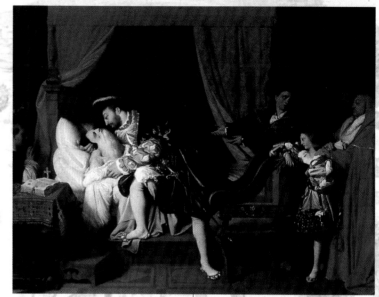

● The discovery of new continents modifies the perception that man has of space, and his way of sensing extension and movement. Science is making progress in the fields of physics and anatomy, and technology applies these principles to the invention of new machines: from hydraulic pumps used for canals and land reclamation to machines of war. Copernicus is studying planetary movement.

♦ JEAN-AUGUSTE-DOMINIQUE INGRES *The Death of Leonardo* (1818, Paris, Petit Palais). The artist is dying, as goes the rather fanciful account of Vasari, in the arms of the king, Francis I: the death of a myth is consigned to history.

♦ RAFAEL *Portrait of Baldassarre Castiglione* (1514-15, Paris, Louvre). His friend Rafael admirably portrays the author of Cortegiano. Even Castiglione, like Leonardo, moved to France.

● The years of the pontificate of the great patron Julius II of Rovere begin, which contemporaneously see the work of artists such as Leonardo, Rafael, Bramante and Michelangelo.

♦ PIERO DI COSIMO *The Death of Procri* (1500 ca., London, National Gallery).

● The emigration of intellectuals like Castiglione and Leonardo toward Spain and France begins; Leonardo accepts the invitation of Francis I to move to Amboise, France, where he will remain until his eventual death on May 2, 1519.

THE CIRCLE OF THE MASTER

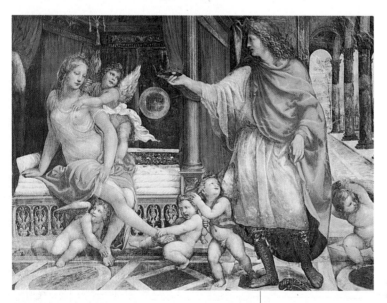

The art of great masters like Leonardo, Michelangelo or Rafael has always produced repercussions, be it in their immediate vicinity or faraway, running in sometimes unpredictable paths. Leonardo had two principal spheres of influence: Florence and Milan. To this, we can add the work produced in France by a student, Andrea Solario, and that produced in the circles of Venice by Giovanni Agostino da Lodi, with reference above all to Giorgione. In Milan there was a true and proper school, actually an academy, that repeated, sometimes in only a pallid way, that slightly melancholy grace and rarefied atmosphere in which Leonardo's creations were immersed. The most noted artists in this circle are Ambrogio De Predis, Giovanni Antonio Boltraffio, Giampietrino, Marco d'Oggiono, Cesare da Sesto, Andrea So-

♦ LORENZO DI CREDI
Portrait of Caterina Sforza
**(Forlì, Civic Museum).
Splendid, with a clear
imprint of Leonardo.**

lario, Bernardino Luini, and Lorenzo di Credi. In Florence, artists such as Andrea del Sarto, Il Sodoma or Fra' Bartolomeo cannot be fully included without a careful reading that takes into account the lesson of Leonardo.

♦ SODOMA (G. A. BAZZI)
*The Wedding of Alexander
and Roxanne*
**(1519-20, Rome, Villa
della Farnesina, fresco).
Although elaborated
in a classical sense,
the lesson of Leonardo
is visible.**

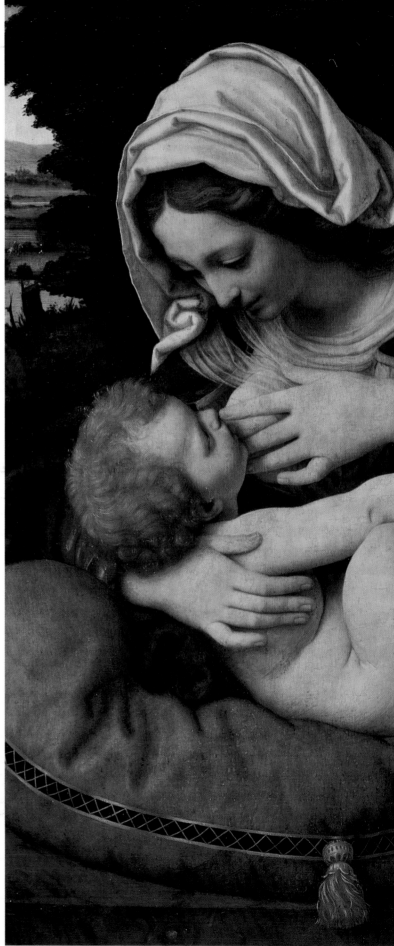

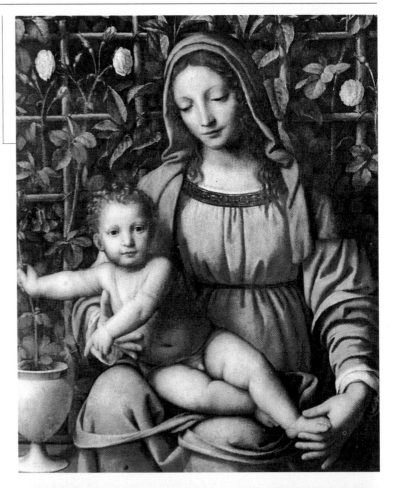

◆ BERNARDINO LUINI
The Madonna of the Rose Garden
Long considered one who vulgarized the pictorial concepts of Leonardo, Luini has now been reevaluated by the critics, who see his best pictorial expressions in the sweet images of the Madonna. Immersed in natural environments, they are characterized by a subtle melancholy and soft, plastic modeling.

◆ ANDREA SOLARIO
Madonna with the green cushion
(Paris, Louvre).
With its brilliant colors and well-pronounced volumes, it is among the works with the strongest imprint of Leonardo that Solario does in France, and that proves to be a determining factor in the diffusion of Italian Renaissance painting. It certainly exercised a strong influence on Jean Clouet and on Holbein and Cranach.

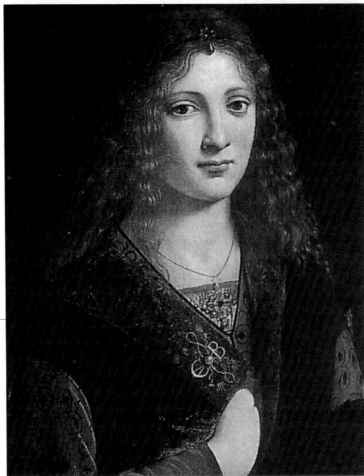

◆ GIOVANNI ANTONIO BOLTRAFFIO
Portrait of a Young Woman
(Chatsworth, Collection of the Duke of Devonshire). Bearing the initials C.B. (Costanza Bentivoglio?). With a transparent and crystalline luminosity, he tempers and renovates the style of Leonardo, of whom he was among the most devoted pupils. His presence in the studio of Leonardo is verified between 1491 and 1498. He participated together with other young artists in the pictorial research of atmospheric rarefaction.

THE ARTISTIC JOURNEY

Leonardo did a limited number of paintings, which still exercised an incalculable influence on sixteenth century European painting, studied and admired as it was by artists from the most varied extractions. To give a complete picture of his personality, we propose here a chronological reading of his principal works, including some drawings and sketches.

◆ DREYFUS MADONNA (1470 ca.)

This Madonna, conserved at the National Gallery in Washington, D.C., is attributed by some to Leonardo, and by others to Lorenzo di Credi. In Dresda, in fact, there exists a preparatory drawing for the drapery attributed to Lorenzo di Credi. The little painting, however, of the highest quality in the figure of the Virgin and in the landscape, could be a derivation of another original by Leonardo.

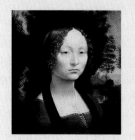

◆ PORTRAIT OF A WOMAN (1473-75)

In the face of the young woman, (we are dealing with Ginevra Benci), we sense an adolescence, which, together with the documents that certify her marriage at the age of seventeen, lead us to suppose that the portrait was done in 1474 for that occasion. The juniper behind the young woman alludes to her name. The picture, conserved at the National Gallery in Washington, D.C., is also painted on the back.

◆ ANNUNCIATION (1470-75)

The painting is the work of Leonardo and the studio of Verrocchio. It has different levels of quality, with sometimes clashing details. For example, some of the architecture, which cannot be referred to the hand of the artist, contrasts with details of the port and profiles of the ships, certainly done by him. The painting, for all the lack of homogeneity in its realization, responds to a single idea of the whole.

◆ JUNIPER AND SCROLL (1474)

That the painting *Portrait of a Woman* was cut not only on the bottom but also on the sides is shown by the back of the same picture, in which a spray of juniper stands out in the center of an arch formed by a palm leaf and a branch of laurel, with a scroll that traverses the width bearing the inscription: "Virtutem forma decorat" (Beauty Decorates Virtue).

◆ MODEL OF DRAPERY (1471-75)

A series of drawings making up part of the artist's study to confer "life-likeness" to drapery. "Lived-in clothes" are preliminary monochrome sketches done by brush on canvas prepared in gray: true and proper virtuosity that puts into practice the directions contained in *Treatise on Painting* by Leonardo, according to which "the clothes which dress the figure must look lived-in".

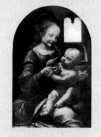

◆ BENOIS MADONNA (1478-80)

The painting is certainly from the first Florentine period, for the strong predominance of its plastic design, which gives the figure a sculpted structure, just softened by a composed and refined intimacy. The diagonal position with respect to the plane of the painting accentuates the embracing effect of the light. A series of drawings studies the positions, movements and bold acrobatics of infant vivacity.

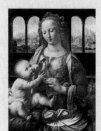

◆ MADONNA WITH THE CARNATION (1478 ca.)

The sure attribution to Leonardo of this painting conserved in Munich is relatively recent. This is based on technical considerations (the craquelure is of the same type as other paintings by Leonardo), and taking into account affinities with other works by the artist of the same period, such as the *Annunciation* at the Uffizi. The Madonna shows similarities in the head and in the treatment of the rich drapery.

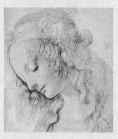

◆ HEAD OF A WOMAN (1475-80)

The drawing, done in pen, bistre, and ceruse at the Uffizi, has long been considered a copy of Verrocchio. Now the critics tend instead to believe it an autographed work of Leonardo, and put it in relation to the Madonna of the *Annunciation* at the Louvre. We are speaking of an early work, but we know well how trained that hand was in daily practice already, before entering the studio of Verrocchio.

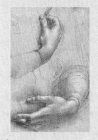

◆ STUDY OF HANDS (1473-76)

The drawing in silver point and ceruse (white lead) has been associated with either a preparatory design for the hands of *The Mona Lisa* or those of *Portrait of a Woman* depicting Ginevra Benci, which has come down to us with the lower part cut off, but of which we know, from a copy, that it used to include the entire bust of the woman. The gesture is also in possible relation to *Lady with the Bouquet* by Verrocchio.

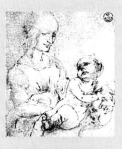

◆ MADONNA WITH THE CAT (1476-78)

Autographed drawings in pen, on gray paper, conserved in Florence in the Cabinet of Drawings and Prints of the Uffizi. Another certainly autographed is in London care of the British Museum and still another in the museum of Bayonne. Paintings with the same subject exist, but none of these, even though derived from the above-mentioned drawings, suggest an attribution to the hand of the master.

◆ THE BAPTISM OF CHRIST (1473-78)

The work, product of the studio of Andrea del Verrocchio, was done with the help of Leonardo and other pupils. The detail of the angel to the left, and the landscape above the heads of the angels, are the hand of Leonardo, which, according to Vasari, already here surpass the master, and put his work into crisis, to the point where it seems that Verrocchio wanted to give up the practice of painting.

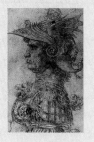

◆ PROFILE OF A CONDOTTIERE (MERCENARY CAPTAIN) (1476-78)

Conserved at the British Museum in London, the drawing depicts the profile of a condottiere with richly decorated helm and body armor. It might refer to a possible sculpture, and the sources on Leonardo speak of youthful activity as a sculptor, in the studio of Verrocchio, relative to a series of laughing children, condottieres, and sculptures of the Madonna.

42

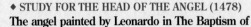

◆ ANNUNCIATION (1478)

The little predella, (16cm x 60cm), at the Louvre, long believed to be an early work of Leonardo, (1478 ca.), is today almost unanimously attributed to Lorenzo di Credi. It comes from the so-called *Madonna di Piazza* in the Pistoia dome. Leonardo's intervention in the ideation and certain details, as is the case with *The Dreyfus Madonna*, *The Ruskin Madonna*, or *The Madonna of Camaldoli*, is possible.

◆ SAINT JEROME (1482)

There are no documentary notes on the painting, but everyone agrees that it dates from the first period in Florence. This and *The Adoration of the Magi* are the two works that the thirty-year-old Leonardo leaves unfinished at the time of his departure for Milan. In the foreground, the curve of the lion's body forms an arc within which is enclosed the action of the saint, who drops to his knees to beat his breast.

◆ STUDY FOR THE HEAD OF THE ANGEL (1478)

The angel painted by Leonardo in The Baptism of Christ by Verrocchio has a study which precedes it on a sheet conserved by the Royal Library of Turin. The model is built with more directions of movement and super-soft shading. The drawing asserts itself immediately in the Florentine circle for its strong, innovative bearing, and is the object of study and replica. More copies of it are known.

◆ FACE OF A WOMAN (1483-84)

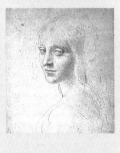

Berenson considers this drawing, conserved at the Royal Library of Turin, "the most beautiful drawing in the world." We are speaking of a preparatory drawing for the angel in *The Virgin of the Rocks* in the Louvre, belonging to Leonardo's phase of studies on "axial motion", that is, on rotational motion of the figure on itself. Some see a portrait of Cecilia Gallerani in the drawing.

◆ STUDY FOR A NATIVITY SCENE (1478-80)

The drawing, done with pen and bistre on slightly pink paper, is conserved at the Metropolitan Museum in New York, and demonstrates an idea which Leonardo worked on without ever completing, even before his conception of *The Adoration of the Magi* at the Uffizi, which was also never completed. Another series of analogous studies prepares for an undocumented picture of *The Adoration of the Shepherds*.

◆ JESUS AND THE BABY SAINT JOHN (1483-1508)

This is a small oil painting with a subject inspired by a verse from the apocryphal Gospels. The painting, currently waiting to by analyzed and restored, is of particular interest from an iconological point of view, situating itself on the boundary between the sacred and the esoteric. Other versions are also known of the same subject, one of which by Marco d'Oggiono, a painter of the Leonardesque school.

◆ CARICATURAL STUDY OF THE HEAD OF A MAN (1481)

This is a large drawing, perforated for pouncing, which makes us think of a study for a painting. The subject belongs to the category of the grotesque, and is known as *The Skirmish Captain of the Gypsies*, recorded also by Vasari. Conserved at Christ Church College of Oxford, the subject, framed at the shoulders, is turning his head, thrusting it into the foreground, with grotesquely caricatured facial features.

◆ PORTRAIT OF BEATRICE D'ESTE (?) (1485 ca.)

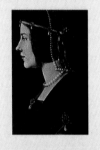

This portrait in the Ambrosian Picture Gallery, attributed to Leonardo, has long been put in relation to Portrait of a Musician, so much so that for a time one was believed to be Beatrice d'Este, and the other Ludovico il Moro. Once the identification with Ludovico il Moro falls, the feminine portrait, also called Lady with the Snood of Pearls, loses its usual interpretation.

◆ ADORATION OF THE MAGI (1482)

Behind the main scene is the entire symbology of the invisible to which *The Adoration* alludes. On the ruins at the left, nature and busy life are reborn; in the center the stairs, symbol of conjunction, climb towards the sky; on the right the battle rages: life and death contend for the field. And among the ruins of the past, the arches and stairs, sink the roots of the trees, which regenerate nature.

◆ PORTRAIT OF A MUSICIAN (1487 ca.)

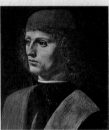

This portrait, conserved in the Ambrosian Picture Gallery in Milan, has been recently reconsidered as an original work of Leonardo. The person depicted seems to be identifiable with the Master of the Chapel of the Dome of Milan, Franchino Gaffurio. The work should thus have been done during the first stay in Milan, between 1485 and 1499.

◆ STUDY FOR ADORATION OF THE MAGI (1481-82)

It is the only surviving study for a first composition of *Adoration of the Magi*. The crowding of people which will later characterize the painting are already in evidence, just as we notice the concordant elements in the vaulted architectural structure, with two staircases upon which are crouching some figures. The group of people in the foreground, however, will come to be set in a semicircle.

◆ LADY WITH THE ERMINE (1485-90)

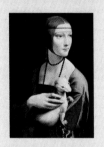

This portrait has been in Krakow since the eighteen-seventies, and is now almost unanimously attributed to Leonardo. In the past, it was ascribed to d'Oggiono, Boltraffio and de Predis, but the great majority of critics are now for Leonardo. The subject is to be identified with Cecilia Gallerani, a young, beautiful woman endowed with a subtle ingenuousness, who was also in friendly rapport with Leonardo.

◆ STUDY OF FLOWERS (1481-82)

The drawing is of high quality, but there are some doubts about the authorship of Leonardo. Apart from the easily recognizable violets, the dog rose, and the buttercup, the rest generally lack correspondence between foliage and flowers, while we know that Leonardo usually traced flowers and leaves from nature. Probable that Leonardo left the drawing unfinished, and another subsequently finished it.

◆ BUSTS OF TWO MEN FACING EACH OTHER (1490-95)

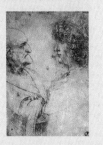

This study, conserved in the Cabinet of Drawings and Prints at the Uffizi, presents the figures of an old man and a young man in profile, one facing the other. Leonardo's interest in the classical world is revealed in a group of drawings of models that in those years came to be portrayed either on the pages of manuscripts in miniature, or in marble bas-reliefs.

◆ STUDY FOR THE CASTING OF THE SFORZA MONUMENT (1493)

In 1493, after long reflection and careful calculations, Leonardo delivers the clay model of the Sforza Monument ready for its casting, which comes to be postponed, however. The side study is extraordinary be it for its technical planning, its anatomical structure, or its use of fireclay. The French will then destroy the model in 1499, when they take Milan.

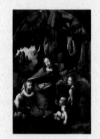

◆ STUDY OF A COUNTRY PLANT AND OAK (1493-98)

This drawing in the Windsor Royal Library is referable, according to some, to the lunettes in the refectory of Santa Maria delle Grazie that overhang *The Last Supper*. These contain enclosed in garlands of vegetables, the heraldic symbols of Sforza dynasty. According to others, they should be put in relation to the Sala delle Asse, in which a thick intertwining of foliage is developed.

◆ THE VIRGIN OF THE ROCKS (1493-1508)

It is not yet clear why, after many years, Leonardo would do a second version of the same subject, today conserved in the National Gallery of London. An economic or theological controversy probably broke out among the Brotherhood of the Immaculate Conception, who commissioned the painting. Although the paintings bear a strong resemblance, there are notable differences between them.

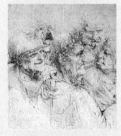

◆ GROUP OF FIVE HEADS (1495 ca.)

The group excited much curiosity among the critics for the possible interpretation connected to a handwritten note of Leonardo's which alludes to the difficulty of those who "possess some goodness" to find people whom they can trust: "enemies are bad but friends are worse". Conserved in Windsor, the drawing in pen and sepia ink presents personality studies at the limits of bestial characterization.

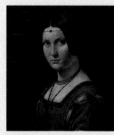

◆ LA BELLE FERRONNIERE (1495 ca.)

The title of this portrait comes from a double entendre in relation to "la Belle Ferronniere" (the wife of a blacksmith), lover of Francis I. Catalogued for years in Fontainebleau as *Portrait of a Duchess of Mantova*, today it tends to be identified with the young and beautiful Lucrezia Crivelli, lover of Ludovico il Moro. The quality of the painting is referable to Leonardo, but some critics attribute it to Boltraffio.

◆ STUDY OF A LILY (1495 ca.)

The drawing, in pen and watercolor on charcoal, is conserved by the Royal Library of Windsor. The precise rendering and scientific calligraphy with which Leonardo attends to botanical details leaves all the critics in agreement as to the attribution of the drawing to the master. The study has most often been put in relation to a painting of *Madonna and Child Who Holds a Lily*, which would have been done for Francis I.

◆ STUDIES FOR A LAST SUPPER; GEOMETRIC AND ARCHITECTONIC STUDIES (1495-96)

The sketch for *The Last Supper* begins to delineate that dynamism of expressions and gestures which will later be the principal characteristic of the fresco. Pillars and frontally framed arches are to be seen, sketched on the back of the work. The drawings on the lower part concern the construction of an octagon from a given line, inverted arcs, and plans of buildings.

◆ STUDY FOR A LAST SUPPER (1495-96)

The rather coarse use of poor quality sanguine made some people think that this might be a fake, or a first attempt to use this means, or a false attribution. Then, this large sheet was interpreted instead as an attempt on the part of Leonardo to see the effect of a composition sketched in greater proportions. Only the figure of the apostle Simon finds its way into the fresco.

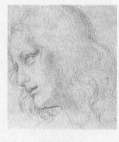

◆ STUDY OF A HEAD (1495-97)

Various head studies for the apostles of *The Last Supper* were accomplished. This one, conserved by the Royal Library of Windsor, depicts the apostle Philip at the moment of Christ's dramatic announcement. The drawing, done in charcoal – a relatively new technique used by Leonardo – gives to the subject a soft and shaded tenderness of expression.

◆ POLYHEDRON WITH SCROLLS (1496-99)

The friar and mathematician Luca Pacioli was a great friend of Leonardo, who with pride affirmed having learned "from Master Luca the multiplication of roots." For Pacioli's treatise *On Divine Proportions*, Leonardo drew polyhedra and other geometric forms that bring to mind those done in marquetry at Santa Maria in Organo in Verona by Brother Giovanni da Verona between 1492 and 1499.

◆ VEGETAL INTERWEAVE OF THE SALA DELLE ASSE (1498-99)

The beautiful ceiling painted by Leonardo and helpers in the grand Sala delle Asse of Sforza Castle is a grand allegory of the "Vinci". At the apex of the vegetal interweave the glorification of the good government of Il Moro is shown by the Sforza family coat of arms. The painting, partly damaged, was reintegrated by 1901, and restored in 1956.

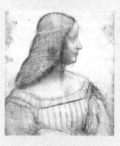

◆ PORTRAIT OF ISABELLA D'ESTE (1499)

With the Marquise of Mantova, Isabella d'Este, Leonardo found welcome when he had to suddenly leave Milan due to the arrival of the French. The perforated cardboard with the portrait of the Marquise reveals his intention to do an oil painting, which the Marquise does request many times. But it seems that Leonardo, overwhelmed by a thousand commitments, never finished it.

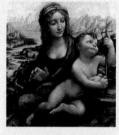

◆ MADONNA OF THE SPINDLES OR REEL (1501)

Known from a letter from Pietro da Novellara to Isabella d'Este dated 1501, this painting comes to be described as "a Madonna who sits as if she wanted to reel in spindles" while the Child plays with the reel that suggests the form of the cross. Three versions of it are known; this one, which is found in New York in a private collection, seems to be the one most ascribable to the hand of Leonardo.

◆ SCUFFLE OF HORSEMEN, AND A STUDY OF THE MOVEMENTS OF NUDE BODIES (1503-1504)

This drawing is part of the preparatory series for *The Battle of Anghiari*. The upper portion shows two opposing masses of horsemen who engage each other, forming a swirling, chaotic movement. In the lower portion there are figures of nude men with lances and slingshots in hand, studied in various dynamic movements of battle.

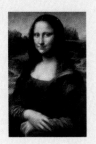

◆ MONA LISA (LA GIOCONDA) (1503-1510)
Dressed in dark clothes, unadorned, she seems more an ideal figure than a portrait taken from life. Freud interprets her as the idealization of the mother figure, projected from memory into an infinite distance. If all this is true, the identification of the subject with Mona Lisa of Giocondo still remains, and the dating of the picture must be moved forward to the moment of Leonardo's full artistic maturity.

◆ STUDY OF A FORTRESS (1504 ca.)
The activities that Leonardo develops as a military engineer be it in Milan or in the service of Cesare Borgia are born witness to by many drawings in the Codices of Madrid. This one here is a project for a fortified body with ravelins that reflects Leonardo's awareness of the *Treatise on Civil and Military Architecture* by Francesco di Giorgio Martini, older than him, and expert in the field.

◆ COURSE OF THE RIVER ARNO (1504 ca.)
The course of the river from Florence to the sea is traced on the map of Tuscany. The canal, which anticipated the deviation of the Arno River from Pisa, in the hydrogeologic planning project for the territory of the Republic of Florence, is also visible. This canal would have avoided flooding in the city, but could also have deprived the city of supplies and traffic via the sea in case of hostilities with Florence.

◆ LEDA ON HER KNEES WITH THE SWAN (1505 ca.)
Around 1503-1505, there was already a first draft of *Leda with the Swan*, which anticipated the woman's figure on her knees, as is evident in this drawing conserved at Chatsworth, care of the collection of the Duke of Devonshire. Only later would the Leda, symbol of the regenerative power of the Earth, become a standing figure, as is noted in the paintings.

◆ HEAD OF LEDA (1505-10)
Some preparatory studies for the *Leda* conserved at Windsor deal with the head and hair of the woman. The pleasure with which Leda is regarding her children, born from her union with Jove, who had transformed himself into a swan, is already apparent in this drawing, which is very similar to the painting named *Leda di Vinci* of the Uffizi Gallery in Florence, except for the hairstyle.

◆ LEDA DI VINCI (1505-10)
A *Leda* painted on wood was named by Anonimo Gaddiano and then by Lomazzo as among the works of Leonardo brought to France. A perforated cardboard with the same subject is also often cited by the sources. It is possible that the original *Leda*, described as greatly damaged by the seventeenth century, was lost, leaving only replicas, more or less traceable to the hand of Leonardo, as is this one.

◆ STUDY FOR THE TRIVULZIO MONUMENT (1508-10)
Gian Giacomo Trivulzio, powerful supporter of the coming of the French to Milan and true master of the city, commissioned his sepulchral monument to Leonardo, who conceived it as a four-fronted arch, overhanging the San Celso Chapel, crowned with the figure of a knight on a rampant horse. The drawing can be related to the small bronze statue in Budapest, attributed to Leonardo.

◆ HEAD OF A MAN IN PROFILE (1508-11)
The drawing, in the Gallery of the Academy in Venice, should be placed in the closest relation to those analogous ones in Windsor and Turin. Beyond simply testifying to Leonardo's interest in classically inspired profiles, the drawing could represent a study for a portrait of a condottiere (mercenary captain). Meller has suggested a reference to Gian Giacomo Trivulzio.

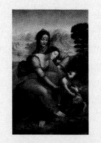

◆ SAINT ANNE, THE MADONNA AND CHILD, WITH THE LAMB (1510)
The never-finished painting belongs to the last phase in Leonardo's formal research. The group, inserted in a precise, pyramidal setting, broken by the tension of the movement of the Virgin, has a profound connection to the surrounding environment. The dialogue between the group of figures and nature unfolds itself in a rarefied atmospheric medium.

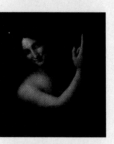

◆ SAINT JOHN THE BAPTIST (1510-14)
The painting in the Louvre seems like the ideal continuation of the *Angel of the Annunciation*, of which Vasari also speaks to us, and which is known only through replicas. The position of the head, the arm raised, with the finger pointed upwards, the rotation of the bust, the flowing hair, the slightly mocking smile, and the ambiguous sensuality, which had it mistaken for a Bacchus, are the elements in common.

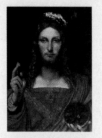

◆ SALVATOR MUNDI (AFTER 1510)
This version, in a private collection, is the work of Leonardo's studio; however, it is to be put in relation to the series of drawings signed by the master, conserved in Windsor. A painting of this subject was donated to Scipione Borghese by Pope Paolo V as a work of Leonardo, but that painting, still in the Borghese Gallery, is now held to belong to the circle of Leonardo, but not to the master.

◆ BACCHUS (after 1510)
The *Bacchus* in the Louvre was originally a *Saint John the Baptist in the Desert*, that Cassiano del Pozzo describes as an ambiguous work and hardly effective as far as its sacredness. With the passage of time, the naturalistic interpretation gained the upper hand and the work came to be transformed into the figure of Bacchus, adding the typical attributes of the god: vine-leaves and panther's skin.

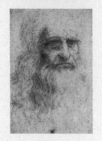

◆ SELF-PORTRAIT (1515 ca.)
The physiognomic characteristics of Leonardo are all summed up in this famous sanguine of Turin: the ample forehead, the aquiline nose, the mouth with the lower lip jutting out, the prominent chin. The problem is that this is a picture of an old man, while at the time of the traditional dating of the self-portrait (1503), Leonardo was little more than fifty. The date should therefore be moved to the last years of his life.

◆ THE GIRL WHO POINTS BEYOND THE VISIBLE (1516 ca.)
Parallel to his studies of the outbreak of natural elements (downpours, tempests, gusts of wind, etc.), Leonardo also studies the effect produced by the wind and movement itself on clothes. This is the case in the *Dancers* of Venice, and the *Pointing Lady* of Windsor, in which the theme is just this clothing agitated by the wind.

The following pages contain: some documents useful for understanding different aspects of Leonardo's life and work; the fundamental stages in the life of the artist; technical data and the location of the principal works found in this volume; an essential bibliography; basic notes on the codices.

DOCUMENTS AND TESTIMONIES

Leonardo painted by Bandello

The writer Matteo Bandello, nephew of the Prior of Santa Maria delle Grazie, arrives in Milan in 1495 and, as a young man, has the opportunity many times to observe Leonardo at work in the refectory holding The Last Supper. *In this way, with the aid of his memory, he will later describe him in one of his short stories.*

"He was often in the habit, and I saw and considered him many times, going at an early hour of the morning and climbing upon the scaffolding, because the Last Supper was so high above the ground: he would be in the habit, I say, from the rising of the sun until the deepening of dusk of not taking the brush from his hand, but forgetting to eat and drink in order to continue painting. Then there would be two, three or four days in which he wouldn't touch it; at such times he would anyway stay two or three hours a day, only contemplating, considering, and examining to himself his figures, judging. I would also see him, (according to the caprice or whim that would touch him), set out at midday, when the sun was at its peak, from the old court where he was building that stupendous horse of clay, and come directly to the Grazie; and climbing upon the scaffolding, take brush in hand, give one or two brushstrokes to one of the figures, and suddenly leave and go elsewhere."

The study of human proportions

A series of notes and drawings contained in the Richter Codex *in the Royal Library of Windsor Castle is part of a group of studies by Leonardo on human proportions datable to around 1490. These considerations, later used by Dürer, above all deal with the dynamic function of the human figure.*

"If one is kneeling, this cuts off a quarter of his height; when a man is on his knees with his hands on his breast, his navel makes half of his height, and similarly the points of his elbows. The half-way point of a seated man, from his seat to the top of his head, is the arm below the breast and below the shoulder; this sitting part, that is, from the seat to the top of the head, is longer than half of the man, by the width and length of the testicles."

[Richter, recto 332].

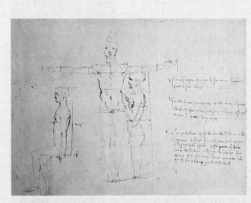

"The forearm is the fourth part of the height of the man and is similar to the greatest width of the shoulders: from one shoulder joint to the other makes two heads and is similar to the distance from the top of the chest to the navel; from this aforementioned summit to the start of the arm makes one head."

[Richter, verse 322].

The "Preservation of health"

Leonardo conducts anatomical studies dissecting cadavers at the medical school. And it is in this environment that he gains the most elementary notions of health and hygiene, which he then re-proposes here and there in some interesting annotations.

"If you want to stay healthy, observe this norm: don't eat without desire and sup lightly; chew well, and let what you receive in your body be well cooked and of simple form. Whoever takes medicine is badly informed; guard against anger and flee from a heavy spirit: be upright, when you leave the table; after midday, see that you don't sleep. Drink wine temperately, little and often, only during meals, and not on an empty stomach: don't make wait, nor prolong the toilet: if you exercise, use small movements. Don't slouch your stomach or lower your head, and stay well-covered at night; put your head down, and have a light mind; flee from luxury, and watch your diet."

[Atlantic Codex, verse 213].

Perfection, grace, admirable and celestial beauty

The myth of Leonardo is born while the artist is still alive and at his death, the passages from Lives *of Vasari which describe him help augment considerably the esteem regarding his boundless genius.*

"Leonardo was truly admirable and celestial in all that nature favored him with, that wherever he turned his thought, his brain and his spirit, he showed so much divinity in the things he did, that in giving perfection to quickness, vivacity, excellence, beauty and grace, no other was ever his equal. We can see that Leonardo began many things, from his artistic intelligence, and never finished any of them, his hand seemingly unable to bring to the perfection of art the things he was imagining: it must be that he formed in idea subtle difficulties so marvelous that with his hands, even as excellent as they were, they would never be expressed. It is an admirable thing that this genius, having the desire to give grand relief to the things he was doing, went so much into the dark shadows to find in their depths greater darkness, that he would look for blacks that would shade and darken the other blacks so that the light, through these, would be more clear, and in the end the light succeeded in this way to be so colored, that, not remaining light, having more forms of things done to replicate a night, than the refinement of the light of day; but all this was in the interest of providing greater relief, and to achieve the ends and perfection of art. [...] To the art of painting, he added a way of coloring a certain darkness with oils, and because of this, modern painters have given great force and relief to their figures..."

[G. Vasari, *Le Vite (Lives)*, 1568²]

HIS LIFE IN BRIEF

1452. Leonardo is born on April 15th in Vinci. He is the illegitimate son of Piero di Antonio, notary.
1469. Enters, according to the opinion of the majority of critics, the studio of Andrea del Verrocchio.
1472. Comes to join the Company of Saint Luke, which shelters painters. Begins to execute his first works.
1473. Finishes, dating it August 5th, the painting depicting a *Landscape with the Arno River Valley.*
1476. Is accused of sodomy; in the same year he is acquitted of the charge.
1478. Receives the commission for an altarpiece to be placed in Signoria Palace. Brings to completion two paintings depicting the Virgin, one of which is identified as the *Benois Madonna.*
1481. Signs the contract for *The Adoration of the Magi.*
1482. Moves to Milan.
1483. In this Lombard city, he is commissioned to paint *The Virgin of the Rocks* together with Evangelista and Ambrogio De Predis.
1489. Creates scenographic displays to celebrate the wedding of Giangaleazzo Sforza and Isabella d'Aragona. Begins to work on the colossal equestrian statue for Francesco Sforza.
1492. Designs costumes for the occasion of the matrimony of Ludovico il Moro and Beatrice d'Este.
1495. Begins work on *The Last Supper* and the decoration of the small rooms in Sforza Castle.
1498. Finishes decorating the Sala delle Asse in Sforza Castle.
1499. In the company of Luca Pacioli, he leaves Milan, moving first to Vaprio, then to Mantova.
1500. In March he is in Venice; then he re-enters Florence, lodging with the convent of the Servants of the Most Holy Annunciation.
1502. Follows the Romagna military campaign of Cesare Borgia, who has hired him as architect and engineer.
1503. Is again in Florence, where he paints *The Mona Lisa.* Is commissioned to paint *The Battle of Anghiari.*
1506. Leaves Florence again for Milan.
1509. Studies the geology of the Lombard Valley. Begins to interest himself in human anatomy.
1513. Moves to Rome, where he stays for three years under the protection of Giuliano de' Medici, dedicating himself to scientific studies.
1517. Moves to Amboise, France, to the court of Francis I.
1519. Dies on May 2nd, leaving his friend Francesco Melzi as executor of his will.

WHERE TO SEE LEONARDO

In the following list are reported the statistics concerning the principal works of Leonardo, conserved in Italian and foreign museums and public collections.
The list is in alphabetical order, for both cities and works. Every item contains title, dating, technique and support, size (in centimeters).

KRAKOW (POLAND)
Lady with the Ermine, 1489-90; oil on wood, 54x39; Czartoryski Museum.

FLORENCE (ITALY)
Adoration of the Magi, 1481-82; sketch on wood, 246x243; Gallery of the Uffizi.

Annunciation, 1475 ca.; oil on wood, 98x217; Gallery of the Uffizi.

Baptism of Christ by Andrea del Verrocchio, 1472-75; oil on wood, 177x151; Gallery of the Uffizi. The head of the angel to the left is attributed to Leonardo.

Landscape of Santa Maria of the Snow, 1473; drawing with pen, 19.6x28; Gallery of the Uffizi, Cabinet of Drawings and Prints.

LONDON (ENGLAND)
Saint Anne, the Madonna, the Child, and the Young Saint John, 1508; cardboard with charcoal, ceruse (white lead), and stumping, 139x101; National Gallery.

Study for the equestrian monument to Gian Giacomo Trivulzio, 1510 ca.; drawing with silver point on paper, 18.9x14.5; Windsor, Royal Library.

Virgin of the Rocks, 1493-1508; oil on wood, 189.5x120; National Gallery.

MILAN (ITALY)
Portrait of Beatrice d'Este (?), 1485 ca.; oil on wood, 51x34; Ambrosian Picture Gallery.

Portrait of a Musician, 1487 ca.; oil on wood, 43x31; Ambrosian Picture Gallery.

Vegetal interweave in the hall named delle Asse, 1498-99; mural painting; Sala delle Asse, Sforza Castle.

MUNICH (GERMANY)
Madonna with the Carnation, 1472 ca.; oil on wood, 62x47; Alte Pinakothek.

PARIS (FRANCE)
Annunciation, 1478; tempera on wood, 14x59; Louvre.

Bacchus, after 1510; tempera and oil on wood transferred to canvas, 177x115; Louvre.

La Belle Ferronnière, 1495 ca.; oil on wood, 63x45; Louvre.

Portrait of Isabella d'Este, 1499; black pencil, sanguine and pastel on paper, 63x46; Louvre.

Portrait of Mona Lisa of Giocondo (La Gioconda), 1503-10; oil on wood, 77x53; Louvre.

Saint Anne, the Madonna and Child, with the Lamb, 1510; oil on wood, 168x112; Louvre.

Virgin of the Rocks, 1483-86; oil on wood transferred to canvas, 199x122; Louvre.

PARMA (ITALY)
La Scapigliata (The Disheveled Woman), 1506-8; umber, green earth and ceruse on wood, 24.7x21; National Picture Gallery.

ROME (ITALY)
Saint Jerome, 1480-82; tempera and oil on wood, 103x75; Vatican Picture Gallery.

SAINT PETERSBURG (RUSSIA)
Benois Madonna, or with the Flower, 1478 ca.; oil on wood transferred to canvas, 48x31; Ermitage.

Litta Madonna, 1478-80; oil on wood transferred to canvas, 42x33; Ermitage.

TURIN (ITALY)
Scythed chariots, 1490 ca.; drawing; Royal Library.

Self-portrait, 1515 ca.; drawing with sanguine, 33.3x21.3; Royal Library.

WASHINGTON D.C. (UNITED STATES)
Dreyfus Madonna, 1470 ca.; oil on wood, 15.5x12.7; National Gallery of Art.

Portrait of a Woman, 1474; oil on wood, 42x37; National Gallery of Art.

BIBLIOGRAPHY

The bibliography on Leonardo da Vinci is endless. In the following list, only some essential indications are furnished, useful for gaining the first tools of orientation and information. To have a complete look at the immense bulk of Leonardesque studies, it is expedient to consult the repertory of the *Bibliografia Vinciana* of Ettore Verga, that of *Raccolta Vinciana* (from 1905 until today), and that of *Bibliotheca Leonardiana* (1493-1989). The eight volumes of *Academia Leonardo Vinci. Journal of Leonardo Studies and Bibliography of Vinciana*, edited by C. Pedretti, are also greatly helpful.

1940 A. Blunt, *Artistic theory in Italy 1450-1600,* Oxford

1954 B. Berenson, *Italian painters of the Renaissance,* London

AA. VV., *Leonardo. Saggi e ricerche,* Istituto Poligrafico dello Stato, Roma

1965 R. Monti, *Leonardo,* Sansoni, Firenze

1967 A. Ottino Della Chiesa (edit.), *L'opera completa di Leonardo pittore,* introduction by M. Pomilio, Rizzoli, Milano

1968-69 K. Clark, *A Catalogue of the Drawings of Leonardo da Vinci in the Collection of Her Majesty the Queen at Windsor Castle,* London, II ed., with the collaboration of C. Pedretti

1974 AA. VV., *Leonardo,* edited by L. Reti, Mondadori, Milano

1976 M. Rosci, *Leonardo,* Mondadori, Milano

1977 AA. VV., *Leonardo. La pittura,* Giunti Martello, Firenze

1982 L. Cogliati Arano, A. Marinoni (edit.), *Leonardo all'Ambrosiana,* Electa, Milano

M. Cianchi, *Le Macchine di Leonardo,* introduction by C. Pedretti, iconography by A. Vezzosi, Becocci Ed., Firenze

1983 S. Béguin, *Léonard de Vinci au Louvre,* RMN, Paris

1985 AA. VV., *Leonardo. La pittura,* Giunti Martello, Firenze. Text by Argan, Berti, Marchini, Brown, Alpatov, Kustodieva, Heydenreich, De Campos, Becherucci, Gould, Brizio, Rosci, Russoli, Rzepinska, Arasse, Pedretti, Huyghe, Clark, Rudel, Meller, Calvesi, Fabian

1987 C. Pedretti, A. Chastel, P. Galluzzi, *Leonardo,* in "Art Dossier", n.12, Firenze

AA. VV., *Disegni e dipinti leonardeschi delle collezioni milanesi,* edited by G. Bora, L. Cogliati Arano, M.T. Fiorio, P.C. Marani, Electa, Milano

1988 L. M. Baktin, *Leonardo da Vinci,* Laterza, Roma-Bari

1990 P. Brambilla Barcilon, P.C. Marani, *Le lunette di Leonardo nel refettorio delle Grazie,* Olivetti, Milano

1991 M. T. Fiorio, P. C. Marani, *I Leonardeschi a Milano. Fortuna e collezionismo,* Electa, Milano

1992 M. Cianchi, *Leonardo. I disegni,* in "Art Dossier", n.67

P. C. Marani, G. Nepi Sciré (edit.), *Leonardo e Venezia,* Bompiani, Milano

1994 AA. VV., *Leonardo artista delle macchine e cartografo,* edited by R. Campioni, introduction by C. Pedretti, Giunti, Firenze. Catalogue of the Imola Exhibition

M. Carminati, *Cesare da Sesto 1477-1523,* introduction by G. A. Dell'Acqua, Jandi Sepi, Milano

1995 A. Chastel, *Leonardo da Vinci. Studi e ricerche 1952-1990,* Einaudi, Torino

E. Camesasca, *Leonardo. Trattato della pittura,* TEA, Milano

F. Caroli, *Leonardo. Studi di fisiognomica,* Leonardo, Milano

M. Cianchi, *Leonardo. I Codici,* in "Art Dossier", n.100, Firenze

S. Zuffi (edit.), *Leonardo da Vinci. Della natura, peso e moto delle acque. Il Codice Leicester,* introduction by F. Zeri, Electa, Milan. Catalogue of the Exhibition of Venice, Milano and Roma

THE CODICES

These are collections of original sheets of Leonardo, full of notes, annotations, sketches, drawings, reflections, verse, memoranda, different by theme, dating and format. The Junta of Florence has reproduced the Codices in facsimile within the national edition of the works of Leonardo.

A useful working tool for the classification of the contents of the individual codices is in the two volumes of J.P. Richter, The Literary Works of Leonardo da Vinci, *London, 1883 and Oxford, 1939, with the updated version by C. Pedretti,* Commentary, *Oxford, 1977.*

ARUNDEL CODEX

London, British Museum: Includes 283 pages of varied format, divided into files (the prevalent format is 21cm x 15cm).

ATLANTIC CODEX

Milan, Ambrosian Library: this is the largest of all the collections. The name is derived from the large format, like that of an atlas. Includes 1750 fragments reunited by Pompeo Leoni on 401 pages of 65cm x 44cm, towards the end of the 16th century.

FRENCH MANUSCRIPTS

Paris, Institute of France: These are the codices that Napoleon Bonaparte had moved from the Ambrosian Library to Paris in 1795. These are pocketsize notebooks, probably used for outdoors note taking, for their handiness.

FORSTER CODICES

London, Victoria and Albert Museum: there are three, even ones of tiny notebook size (circa 15cm x 10cm).

HAMMER CODEX

Washington, D.C., collection of Bill Gates: known as the Leicester Codex until 1980, then it was sold in auction to the American, Armand Hammer. In 1994 it was again auctioned and sold to the current owner, Bill Gates.

TRIVULZIANO CODEX

Milan, Library of Sforza Castle: originally included 62 pages of 20.5cm x 14cm format. Today, many are missing. Passed to the Library in 1935 with the estate of Prince Trivulzio.

CODICES OF MADRID

Madrid, National Library: include two volumes. They were found again by chance in 1966.

CODEX ON THE FLIGHT OF BIRDS

Turin, Royal Library: collects observations on the behavior of birds in flight in relation to the wind. It is in small format (21cm x 15cm).

WINDSOR COLLECTION

Windsor Castle, Royal Library: in the possession of the English Crown since 1690, it includes 234 pages of circa 48cm x 35cm.

Chagall
One Hundred Paintings
The Falling Angel

Dali
One Hundred Paintings
The Persistence
of Memory

Kandinsky
One Hundred Paintings
The First Abstract
Watercolour Painting

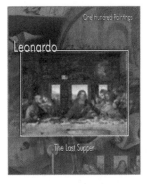

Leonardo
One Hundred Paintings
The Last Supper

Manet
One Hundred Paintings
Le déjeuner sur l'herbe

ONE HUNDRED PAINTINGS:

every one a masterpiece

The Work of Art. Which one would it be?

...It is of the works that everyone of you has in mind that I will speak of in "One Hundred Paintings". Together we will analyse the works with regard to the history, the technique, and the hidden aspects in order to discover all that is required to create a particular painting and to produce an artist in general.

It is a way of coming to understand the sensibility and personality of the creator and the tastes, inclinations and symbolisms of the age. The task of "One Hundred Paintings" will therefore be to uncover, together with you, these meanings, to resurrect them from oblivion or to decipher them if they are not immediately perceivable. A painting by Raffaello and one by Picasso have different codes of reading determined not only by the personality of each of the two artists but also the belonging to a different society that have left their unmistakable mark on the work of art. Both paintings impact our senses with force. Our eyes are blinded by the light, by the colour, by the beauty of style, by the glancing look of a character or by the serenity of all of this as a whole. The mind asks itself about the motivations that have led to the works' execution and it tries to grasp all the meanings or messages that the work of art contains.

"One Hundred Paintings" will become your personal collection. From every painting that we analyse you will discover aspects that you had ignored but that instead complete to make the work of art a masterpiece.

Federico Zeri

Coming next in the series:

Matisse, Magritte, Titian, Degas, Vermeer, Schiele, Klimt, Poussin, Botticelli, Fussli, Munch, Bocklin, Pontormo, Modigliani, Toulouse-Lautrec, Bosch, Watteau, Arcimboldi, Cezanne, Redon

Raphael
One Hundred Paintings
School of Athens

Rembrandt
One Hundred Paintings
Supper at Emmaus

Renoir
One Hundred Paintings
Moulin de la Galette

Rubens
One Hundred Paintings
Garden of Love

Van Gogh
One Hundred Paintings
Starry Night